A BRIEF HISTORY of
CATOOSA COUNTY

A BRIEF HISTORY *of*
CATOOSA COUNTY
UP INTO THE HILLS

JEFF O'BRYANT

Published by The History Press
Charleston, SC 29403
www.historypress.net

Copyright © 2009 by Jeff O'Bryant
All rights reserved

First published 2009

Manufactured in the United States

ISBN 978.1.59629.555.1
Library of Congress Cataloging-in-Publication Data
O'Bryant, Jeff.
A brief history of Catoosa County : up into the hills / Jeff O'Bryant.
p. cm.
Includes bibliographical references.
ISBN 978-1-59629-555-1
1. Catoosa County (Ga.)--History. I. Title.
F292.C2O25 2009
975.8'326--dc22
2008043996

Notice: The information in this book is true and complete to the best of our knowledge. It is offered without guarantee on the part of the author or The History Press. The author and The History Press disclaim all liability in connection with the use of this book.

All rights reserved. No part of this book may be reproduced or transmitted in any form whatsoever without prior written permission from the publisher except in the case of brief quotations embodied in critical articles and reviews.

For my father and mother, whose love and support guide me still.

CONTENTS

Preface	9
Acknowledgements	13
Introduction	15

PART I. EARLY HISTORY

Chapter 1. The Principal People	21
Chapter 2. At the Crossroads	31
Chapter 3. Legacy of a Forgotten Hero	39
Chapter 4. A New County in the Hills of Northwest Georgia	49

PART II. THE CIVIL WAR AND ITS AFTERMATH

Chapter 5. The Andrews Raiders	61
Chapter 6. Chickamauga	69
Chapter 7. The Battle of Ringgold Gap	81
Chapter 8. Reconstruction	91
Chapter 9. The First National Military Park	99

PART III. ENTERING THE TWENTIETH CENTURY

Chapter 10. A New Military Post	109
Chapter 11. The Sixth Cavalry	119
Chapter 12. The Women's Army Corps	129
Chapter 13. The Rest of the Story, Almost…	143

Epilogue	151
Bibliography	153
About the Author	159

PREFACE

"You are either Cherokee or you are not," the man on the other end of the phone politely, but firmly, informed me. "There is no such thing as being 'part Cherokee.'"

In 1997, I called the Cherokee Nation offices in Tahlequah, Oklahoma, in hopes of learning more about the meaning of the word "Catoosa." Several different, but similar, translations for the original word "gatusi" cropped up during my research for the brief history of the county that I was writing for the local historical society's *Heritage Book*. But I had nothing concrete. Did it mean "hill" or "on the hill"? Was it a "high point" or a "small mountain"? Or was it a combination of the words "gatu gitse," meaning "new settlement"? Perhaps it was a minor detail, especially given the fact that my task was to focus on the founding, and subsequent development of, Catoosa County by Europeans and their descendants. But I wasn't about to tell even a part of the tale of Catoosa County without explaining, insofar as was possible, the meaning of its very name.

My call to Tahlequah, I hoped, would settle the matter. I explained to the gentleman why I was calling and what I hoped to learn. In the course of our conversation, I mentioned that I was born and raised in Catoosa County and that somewhere in my family tree (on my mother's side) there was a Cherokee; therefore I was, obviously, part Cherokee. It was something about which I did not often think—indeed, about which I knew very little—beyond the mere fact of it. Mostly, I identified my ancestry, for obvious reasons, with the Irish. But I was nevertheless proud that there was Native American somewhere in the mix.

Preface

Rather than expressing interest in my Cherokee ancestry, as I had expected, the gentleman on the other end of the line paused briefly before informing me that there was no such thing as "part Cherokee." I was immediately concerned that I had offended him, but he pleasantly advised me that I had not. He went on to explain that being Cherokee wasn't about the blood that flowed in your veins; rather, it was a mindset—what, if anything, you learned from your ancestors and how much of that knowledge made you who you are.

And that is what history, ultimately, is about. Its study can often entertain, always inform and hopefully enlighten the current generation to heed George Santayana's warning that "those who cannot remember the past are condemned to repeat it." Perhaps this seems clichéd, but beyond the simple fact that history can and should be enjoyable is the very real counsel it offers to any who study it.

Natives may be interested in Catoosa County history for a variety of reasons and Civil War buffs because of Chickamauga, the Battle of Ringgold Gap and the Andrews Raiders. Others, however, may ask what the average reader or casual historian can possibly learn from the study of a small county nestled in the northwestern corner of the state of Georgia. But one does not ask such a question concerning lessons gleaned from the study of the camps in Nazi-occupied portions of Europe during World War II. Similar camps, while not as horrifying as death camps like Auschwitz, first appeared in North America in the northwestern corner of Georgia. These camps contained Cherokees who lived on land that European descendants wanted, including the area that would one day become Catoosa County. The camps served as holding areas for the Cherokees before their forced removal (now known as the Trail of Tears) to Oklahoma. Of the approximate four thousand deaths that occurred due to the Indian Removal, conditions in the holding camps may be attributed to about one-third.

In history, as in life in general, we learn from both negative and positive lessons, from our mistakes as well as our successes. Fortunately, the treatment of the Cherokees and other negative tales (such as Jim Crow) are not the only lessons Catoosa has to teach. The county's history abounds with examples of determination, bravery, reconciliation and sacrifice. These lessons intertwine with stories of adventure, war and social change, and they form the tapestry of a small cross section of Southern life found at the bottom tip of the Appalachian Mountain system.

Unfortunately, my call to Tahlequah didn't settle the question as to the literal meaning of the word "Catoosa." Since that time, I've discovered other

Preface

possible meanings. According to Nancy Harris Crowe, who authored the Cherokee history of the Catoosa County Historical Society's *Heritage Book*, it means "up in the hills." Though we may never know the actual meaning, up into the hills certainly fits the geography of Catoosa County. Its name also speaks to both the natural beauty and the heritage of the past contained within this ancient land of the Cherokees.

ACKNOWLEDGEMENTS

This effort would not have been possible without those who went before in setting down the history of Catoosa. Susie Blaylock McDaniel's *Official History of Catoosa County, Georgia* and the two volumes of *History in Catoosa County* by William H.H. Clark proved invaluable to the research that went into this volume. Thanks must also be extended to Jemima Shirley and the other members of the Catoosa County Historical Society for their generous support in providing early county photos for this volume, as well as their service to Catoosa in helping to preserve the area's local history. Thanks also to Christine McKeever and April Lane of the 6th Cavalry Museum for their generous support in providing information, as well as Sixth Cavalry, WAC and other post photos that appear in this volume. I am indebted to Connie Haney and the rest of the Catoosa County Library staff for their assistance and support; the *Catoosa County News*, whose initial and continuing support of my musings in the county newspaper helped light the way to this volume; and both the classroom teachers of the Catoosa County School System and the Ringgold High School Junior ROTC instructors who encouraged a well-meaning, but somewhat problematic, student to do his best.

Special thanks to David Kindred and Eric Zinkann, friends with whom, while growing up, I seemed to have tramped all over Catoosa County—great boyhood years that made those of manhood better. And, lastly, thanks to my wife, Susan, without whose encouragement, support and love this volume would have been impossible.

INTRODUCTION

The earth is a great island floating in a sea of water, and suspended at each of the four cardinal points by a cord hanging down from the sky vault, which is of solid rock. When the world grows old and worn out, the people will die and the cords will break and let the earth sink down into the ocean, and all will be water again. The Indians are afraid of this.

When all was water, the animals were above in Gälùń'lätl, beyond the arch; but it was very much crowded, and they were wanting more room. They wondered what was below the water, and at last Dàyuni'sĺ, "Beaver's Grandchild," the little Water-beetle, offered to go and see if it could learn. It darted in every direction over the surface of the water, but could find no firm place to rest.

Then it dived to the bottom and came up with some soft mud, which began to grow and spread on every side until it became the island which we call the earth. It was afterward fastened to the sky with four cords, but no one remembers who did this.

—*From the Cherokee creation myth*

At the beginning of the Paleozoic era—roughly 500 million years ago—the 162.2 square miles that would one day form Catoosa County lay underwater. The supercontinent of Pangaea was in the initial stages of formation and would eventually make up most of the surface area of the earth, developing into a single enormous landmass. Over the course of the supercontinent's formation and subsequent breakup into the familiar continental configuration recognized today, the area of northwestern Georgia went through various climatic changes. After

Introduction

the waters receded, in roughly 100-million-year periods, the land became vegetation-covered lowland, then a desert and then a forested highland before becoming lowland again. For the last 100,000 years, and into the present, the area has comprised a forested highland that forms a series of discontinuous, northeast-trending valleys. Sedimentary rocks—most notably limestone, but also including sandstone, shale, dolomite and chert—exist throughout the county.

The Paleo-Indians were the first human beings to live in the area comprising modern-day Georgia, and evidence of their habitation extends perhaps as far back as eleven thousand years. They likely arrived via the long-vanished land bridge that connected Asia to North America near the end of the last ice age. They were hunter-gatherers who traveled in extended family groups, probably no larger than fifty people, and made use of tools made from stone and bone.

Following the Paleo-Indians were the Mound Builders. These Native Americans were likely the ancestors of the more familiar Native Americans such as the Creek, Choctaw and other tribes. Different mound-building cultures had different purposes for the mounds—some shaped the mounds into animals, some used the mounds as burial grounds, others used mounds as ceremonial sites and still others used them as monuments or temples. The Mound Builders lived in large groups, cultivated the land, engaged in trade and lived within a complex hierarchical society. In the Southeast, including present-day Georgia, the Mississippian Mound Builders thrived for nearly seven hundred years before Columbus reached the New World, but shortly thereafter—about the middle of the 1500s—their numbers declined. Though nothing survives of the Mound Builders in Catoosa, the heaps of earth that once existed near I-75 in Ringgold were perhaps sites left behind by this ancient group of Native Americans.

The Gap

By the time of European exploration, the Cherokee and Creek tribes controlled the area, though the Cherokees eventually succeeded in pushing the Creeks out of north Georgia toward the Gulf. The arrival of Hernando de Soto in Florida in 1539 sowed the seeds of the eventual downfall of the Cherokees. The explorer and his men set out on an expedition that lasted four years and covered almost one million square miles of the Southeast (even coming to within just a few miles of passing through present-day Catoosa). But they also spread European diseases that decimated the Native

Introduction

American population. For the next one hundred years, the Spanish built missions and spread the Roman Catholic faith, but they killed far more than they converted: an estimated 75 percent of the total Cherokee population died. The technology of the Europeans already gave them a tremendous edge over Native Americans, but it was the decimation of native tribes by disease—especially smallpox—that, more than any other single factor, led to their eventual forced migration westward.

Their removal, however, was a slow process, and it was not without moments of successful resistance. The tribe's oral histories indicate that the Spanish had settlements north of present-day Catoosa. The Cherokees pushed back these encroachments into their territory by 1600, and the Spanish formed a new settlement on what is today the Catoosa Training Facility (more popularly known as the "Rifle Range"). If the oral histories are correct, a portion of a stone wall along the ridge of Sand Mountain may be the last visible signs of the Spanish settlement, offering evidence that Europeans made it to present-day Catoosa County two hundred years before the previously supposed years of the early 1800s.

When Great Britain officially chartered the colony in 1732, the Spanish had already abandoned Georgia. Settlers from Charles Town, aided by Native American allies, drove them out. But Spain had not yet given up hope of reclaiming its lost territory from the British, and in 1739 the War of Jenkins's Ear broke out between the two powers. In 1742, the Spanish invaded Georgia but met defeat at the hands of James Oglethorpe and his men at the Battle of Bloody Marsh, near Fort Frederica. After this defeat, the Spanish never returned to Georgia.

The French were the next to fall. In 1754, the French and Indian War broke out between France and Great Britain. Despite the war's somewhat misleading name, both sides received Native American support, though the French enjoyed more than the British. This extra assistance was not enough, however, and the British claimed victory in 1763. The war itself had nothing to do with the colony of Georgia, but its aftermath—principally the establishment of the British as the dominant power in North America—did.

Under British rule, the colony eventually prospered. Settlers raised cattle and hogs, developed a booming fur trade with the Native Americans and produced lumber, pitch and tar. Through slave labor, plantations grew rice, indigo, tobacco and wheat. Cotton, not yet "king," wouldn't come to dominate Southern crop production until after Eli Whitney introduced his gin in 1793. Yet scarcely thirty years would pass before the crop—and the slaves who worked the cotton fields—transformed from

INTRODUCTION

an ever-present, underlying concern to the dominant political issue in the young United States.

By the 1760s, with the French defeated and now out of the picture in North America, Georgia's western limit was set at the Mississippi River and its southern boundary with Florida was extended all the way to the Saint Mary's River. Yet only the eastern portion of the colony contained settlers. The area west of the Appalachians, set aside by King George III's Proclamation of 1763, formed a Native American reservation that excluded settlement by Europeans. The king's goal was to improve relations with Native Americans, establish trade and prevent expensive wars. But by 1776, Georgia's settler population had reached about forty thousand—half of them were slaves, and many in the other half were itching to move westward.

PART I

EARLY HISTORY

CHAPTER 1

THE PRINCIPAL PEOPLE

On the way to Oklahoma, by way of the Trail of Tears, the tribal elders saw many of their people die and many others in despair. The women especially were full of tears and struggled to continue on. Knowing the survival of the Cherokee Nation depended on the survival of the children and that the children's survival depended on the women, the elders called upon their father, Heaven Dweller, and told him of the peoples' suffering and death. Their father heard their cry and promised a sign. The next day the women were told to look back down the trail. There, one for each tear shed, a sign; a white rose blooming before their very eyes. It had seven leaves for the seven clans of the Cherokee. Its center was gold, reminding the tribe of the greed of the white man that forced them from their ancient lands. In addition to its beauty, the rose was sturdy, strong, and very bristly to protect its bloom. At this sight the women set aside their sadness and determined to become like the rose; strong, beautiful, and, as the bristles protected the bloom, they would protect their children. The new Nation of the Cherokee, far west from their original home, would survive and grow.

—*"The Legend of the Cherokee Rose"*

Before Europeans arrived in the New World, Cherokee control extended throughout the Southeastern portion of North America, from the northern tip of present-day Virginia to the eastern edge of present-day Texas. They originally migrated from northern Mexico and portions of Texas to the Great Lakes region, but wars with other Native Americans, both the Iroquois and Delaware tribes, forced them into the Southeast.

The meaning of the name "Cherokee" is uncertain and actually has no substance in the tribe's own tongue. It likely comes from either the word

A Brief History of Catoosa County

"Tsalagi," the Choctaw name for the Cherokees meaning "people of the land of caves," or from the word "Tisolki," the Creek name for them meaning "people of a different speech." It first appeared in 1557 as "Chalaque" in the Portuguese record of de Soto's travels. The British first encountered the Cherokees in 1654 but referred to them as "Rechahecrians," a variation of the Powhatans' name for the Cherokees. The year 1708 is the first recorded use of the word "Cherokee" in the English language. The Cherokees' name for themselves is "Yun'wiya" or "Ani-Yun'wiya," meaning either "real" or "principal people."

The Cherokees developed a complex series of myths and beliefs. They were also skilled and knowledgeable farmers, frequently changing their village sites—which were primarily in or near river valleys—to avoid depleting the soil. They cultivated a variety of crops and also foraged for wild plant foods, hunted game and fished. By the time Europeans first encountered them, they lived in log homes.

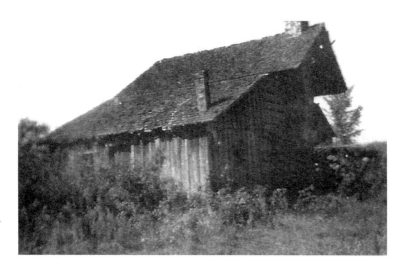

By the time of the removal, many Cherokees lived in much the same way as their European-descended neighbors—they had adopted European religion, style of dress and farming techniques. Many Cherokees already lived in log constructs by the time the Europeans arrived, and they later adopted a similar form of government. However, these modifications to their original way of life were not enough to save them from their forced migration westward. This Cherokee cabin in the Wood Station community stood well into the twentieth century. *Courtesy of the Catoosa County Historical Society.*

Early History

European settlers numbered the Cherokees—along with the Creeks, Chickasaws, Choctaws and Seminoles—among the so-called Five Civilized Tribes due to their relative willingness to change. Many converted to Christianity, and they also assimilated into the culture of the Europeans, adopting similar dress, farming methods and building techniques. They even owned slaves. In 1820, the Cherokees established a republican governing system directly modeled after the United States. Rather than a president, however, they elected a principal chief, but they did form both a senate and a house of representatives, much like those of the U.S. government. In 1827, they adopted their own constitution and formed the Cherokee Nation.

Ultimately, the Cherokees' adoption of many of the customs and ways of Europeans did not protect them. Nor did their obtainment of firearms in 1700 prevent their eventual defeat. They suffered their first cession of land in 1721, when they signed a treaty with Governor Francis Nicholson of South Carolina. Cherokee representatives from thirty-seven towns participated in the process, which led to regulated trade and set a boundary line between Cherokee territory and colonial settlements.

In 1738 and 1739, the Cherokees suffered the ravages of smallpox as about half their number died in the grasp of the contagion, leaving perhaps fewer than fifteen thousand of the estimated thirty thousand Cherokees who lived during the latter portion of the 1600s. By 1755, after war and repeated—though less devastating—outbreaks of the disease, their numbers were again cut approximately in half.

In 1776, when the colonies declared themselves independent from Great Britain, most Native Americans, including the Cherokees, sided with the British. As many as thirteen thousand fought against the Americans. The Cherokees led infrequent attacks on Patriot settlements, but as the war came to a close, they and other Native American tribes sued for peace. They had to. The earlier ravages of smallpox, combined with the ravages of war in both war dead and the resulting circumstances of the conflict (women and children left sick and starving in mountain hideaways), had almost led to the extinction of the tribe. Thus were the circumstances from which they had to negotiate in their first treaty with the young United States of America.

This negotiation, resulting in the Treaty of Hopewell, concluded on November 28, 1785, and not only set boundaries, but established peace as well. Both were short-lived, as settlers were already encroaching on portions of the land established for the Cherokees. Although minor, there were ongoing hostilities between the two sides.

The avaricious desire for land was one thing, but the voracious desire for land with precious metals on it was quite another. The discovery of gold deposits on Cherokee lands in northwestern Georgia, as well as in portions of Tennessee and North Carolina, signified the eventual end of the Cherokees' presence in their ancient home.

Georgians were especially eager to rid themselves of the Cherokees and asked the federal government to intercede and remove them. When this attempt failed, Georgia tried to buy the territory. Incensed, the Cherokee Nation passed a law that forbade any such sale on pain of death. In 1828, to Georgia's shame, the state legislature outlawed the Cherokee Nation and confiscated its lands. With nowhere else to turn, the Cherokees appealed to the federal government.

They first sought the help of then president Andrew Jackson. But Jackson dismissed the Cherokees' request for help and claimed that he had no power to intervene. Jackson, known as a stubborn man who made happen what he wanted to happen, simply had no desire to help the Cherokees. This attitude was common among frontiersmen and, with open land and the prospects of wealth before them, few opposed Jackson's actions. His frequent assertion that he sought to help the common man clearly did not include Native Americans.

The Cherokees then turned to the Supreme Court. Ruling in favor of the Cherokees in *Worcester v. Georgia*, Chief Justice John Marshall argued that the federal government, not state governments, had exclusive jurisdiction over Native American lands. Upon learning of the court's decision, Jackson supposedly exclaimed that "John Marshall has made his decision. Now let him enforce it." This the court was unable to do, and federal authorities simply ignored the decision and instead followed Jackson's policy of removal.

Henry Clay called Jackson's Native American policy a stain on the nation's honor. Though conveniently ignoring his complacency in another stain on the nation's honor (Clay, though holding moderate views on the subject, owned slaves), he was nevertheless correct. And, as events would soon prove, he was even more right than he suspected.

THE TRAIL OF TEARS

With the complacency of Jackson's administration, Georgia proceeded to round up Cherokees for their forced march westward toward Oklahoma. General Winfield Scott (later to serve with distinction in the Mexican War,

Early History

run for president and devise the Anaconda Plan that led to the eventual defeat of the South during the Civil War) oversaw the march.

When Scott arrived, he set up his headquarters at the Cherokee capital in New Echota (present-day Calhoun, Georgia) and shortly issued the following proclamation:

> *Cherokees! The President of the United States has sent me with a powerful army, to cause you, in obedience to the treaty of 1835, to join that part of your people who have already established in prosperity on the other side of the Mississippi. Unhappily, the two years which were allowed for the purpose, you have suffered to pass away without following, and without making any preparation to follow; and now, or by the time that this solemn address shall reach your distant settlements, the emigration must be commenced in haste, but I hope without disorder. I have no power, by granting a farther delay, to correct the error that you have committed. The full moon of May is already on the wane; and before another shall have passed away, every Cherokee man, woman and child in those states must be in motion to join their brethren in the far West.*
>
> *My friends! This is no sudden determination on the part of the President, whom you and I must now obey. By the treaty, the emigration was to have been completed on or before the 23rd of this month; and the President has constantly kept you warned, during the two years allowed, through all his officers and agents in this country, that the treaty would be enforced.*
>
> *I am come to carry out that determination. My troops already occupy many positions in the country that you are to abandon, and thousands are approaching from every quarter, to render resistance and escape alike hopeless. All those troops, regular and militia, are your friends. Receive them and confide in them as such. Obey them when they tell you that you can remain no longer in this country. Soldiers are as kind-hearted as brave, and the desire of every one of us is to execute our painful duty in mercy. We are commanded by the President to act towards you in that spirit, and much is also the wish of the whole people of America.*
>
> *Chiefs, head-men and warriors! Will you then, by resistance, compel us to resort to arms? God forbid! Or will you, by flight, seek to hide yourselves in mountains and forests, and thus oblige us to hunt you down? Remember that, in pursuit, it may be impossible to avoid conflicts. The blood of the white man or the blood of the red man may be spilt, and, if spilt, however accidentally, it may be impossible for the discreet and humane among you, or among us, to prevent a general war and carnage. Think of this, my*

Cherokee brethren! I am an old warrior, and have been present at many a scene of slaughter, but spare me, I beseech you, the horror of witnessing the destruction of the Cherokees.

Do not, I invite you, even wait for the close approach of the troops; but make such preparations for emigration as you can and hasten to this place, to Ross' Landing or to Gunter's Landing, where you all will be received in kindness by officers selected for the purpose. You will find food for all and clothing for the destitute at either of those places, and thence at your ease and in comfort be transported to your new homes, according to the terms of the treaty.

This is the address of a warrior to warriors. May his entreaties be kindly received and may the God of both prosper the Americans and Cherokees and preserve them long in peace and friendship with each other!

The proclamation was a mixture of truth, lies and propaganda. Scott did command about seven thousand troops and had the authority to call up to four thousand more in militia and volunteers from neighboring states. And the threat of bloodshed was also true. Soldiers scoured the countryside in search of any Cherokee habitation and forced families from cabins, houses and fields. But the claims of merciful treatment were often fiction. Cherokees were robbed, their homes were sometimes torched before their eyes and many were physically abused.

Though many came peacefully, several hundred successfully escaped into the mountains—some even after their capture, while they were interred in removal forts. The fugitive Cherokees lived off whatever food they could forage, and Scott, realizing the difficulty of capturing them, allowed them to stay so long as they gave up Tsali, a Cherokee whose escape had led to the death of a soldier. Tsali, also known as Charley, willingly turned himself in when he learned of Scott's decision to allow the fugitives to remain at large if he himself surrendered. He, along with his two sons and his brother, died in front of a firing squad, executed by a group of captured Cherokees forced to carry out the sentence. Tsali's sacrifice was not in vain. Those Cherokees who were still at large eventually formed the Eastern Band of Cherokee who now live in North Carolina.

Georgians seemed especially rapacious to Scott, who was repulsed by their attitude toward the Cherokees—some treated the Native Americans as if they were not even human. If this attitude was not prevalent within the Georgia General Assembly, then something very much like it still reigned within the governing body. In the assembly's haste to parcel out Cherokee

Early History

lands to settlers even before the removal, the State of Georgia passed two new land lottery acts, the last in a series of laws that divided up Native American lands for settlers.

These two land lotteries were passed in 1832—a Gold Lottery and a Land Lottery. Though provisions existed for widows and orphans, the key qualifications required that participants be white, male, eighteen or older, citizens of the United States and residents of Georgia for at least three years. The assembly was to the point and made no mention that its act was little more than legalized theft:

> *An act to authorise the survey and distribution of the lands within the limits of Georgia, in the occupancy of Cherokee tribe of Indians, and all other unlocated lands within the limits of said State, claimed as Creek land, and to authorise the Governor to call out a military force to protect surveyors in the discharge of their duties, and to provide for the punishment of persons who may prevent, or attempt to prevent, any surveyor from performing his duties as pointed out in this act, or who shall wilfully cut down and deface any marked trees, or remove any land mark which may be made in pursuance of this act, and to protect the Indians in the peaceable possession of their improvements, and of the lots on which the same may be situate.*

The lands in northwest Georgia taken from the Cherokees, including the area now comprising Catoosa, made it into the possession of settlers by way of these lotteries. They drew "tickets" and received their "prizes," the last remaining Cherokee lands in Georgia.

How many Cherokees were removed from the area that would one day form Catoosa County is unknown. At that point in history, Catoosa was contained within what was once a much larger Walker County, so numbers are mere estimates. Within the entire north Georgia area there were approximately eight thousand Cherokees rounded up for the removal, and those who did live within the bounds of modern-day Catoosa (roughly twenty-two hundred) made their way to two primary points in their initial steps toward the Trail of Tears: present-day Boynton, on what came to be known as Three Notch Road (named for three notches carved into a nearby oak tree to mark the point where Scott's soldiers would build said road to aid in the removal) and Richard Taylor's Inn and Tavern in present-day Ringgold.

As a descendant of "the Beloved Woman" of the Cherokee Nanye'hi (meaning "one who goes about," but known to settlers as Nancy Ward),

Taylor was from the family line of one who had assumed an almost legendary status among the Cherokees. Ward advocated peace with whites and became something like an ambassador between them and her people. Her descendants intermarried, and Taylor, therefore partially white, nevertheless went on to become a tribal chief. Intelligent like his great-grandmother, Taylor was bilingual, well-educated and intermingled with settler culture without entirely becoming part of it.

Taylor was born on February 10, 1786, and went on to serve with Andrew Jackson at Horseshoe Bend in Alabama during the War of 1812. He also served as an interpreter for Colonel Return Jonathan Meigs and as an Indian agent for the federal government, and he played a significant role in the negotiations between the Cherokee Nation and Washington. When these talks ultimately failed to secure their lands from further encroachment, Taylor was appointed by John Ross, the principle chief of the Cherokee Nation at the time of the removal, as the conductor to one of the detachments of Cherokees on its way to Oklahoma.

Taylor married twice—first to Ellen McDaniel and later to Susan Fields. His tavern, a large log construct that overlooked Chickamauga Creek, was a popular stopping point for travelers, and he became relatively wealthy from its income. His home, Mount Hope, was a 150-acre plantation that stood where Alabama Road and Georgia Highway 2 intersect. Ringgold bore his name as Taylor's Crossroads before it was renamed in 1847, but Taylor's Ridge continues to bear his name to this day. He died in Tahlequah, Oklahoma, on June 15, 1853, at the age of sixty-seven.

From Taylor's inn and Three Notch Road, the Cherokees in the area made their way to the nearby principle departure site: Chattanooga, Tennessee. But before the march westward began in 1838, they faced life in captivity within so-called "removal forts." Approximately seventeen thousand Cherokees found themselves held in these stockades. The nearest of these to modern-day Catoosa County was Fort Cumming, just outside Lafayette, which held approximately five hundred Cherokees. The removal forts rapidly became holes of human misery, plagued by rats, where dysentery ran rampant. Some of the promised food of Scott's proclamation made it into Cherokee hands, but much of it was either consumed by soldiers or illegally sold to local residents. The supplies that did reach the Cherokees were of flour and other provisions that they either did not know how to properly prepare or lacked the appropriate tools to do so. Exact numbers of how many Cherokees died in these camps do not exist. However, camp conditions later contributed to the high death toll on the march itself. Approximately one-third of the

Early History

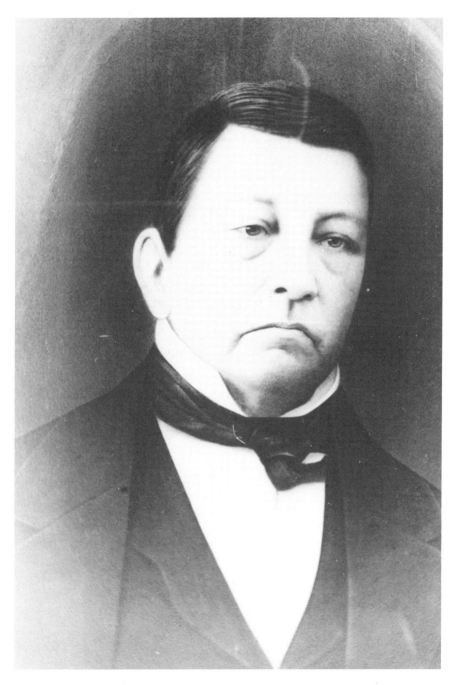

The village of Ringgold once bore the name of Cherokee Chief Richard Taylor, and his inn in the small town served as a principle stopping point along the Old Federal Road. *Courtesy of the Library of Congress, LC-USZ62-109119.*

Cherokees who died during the march succumbed, in large part, due to their weakened condition brought about by their stay in the camps.

Scott's proclamation spoke of "ease and in comfort" concerning the trip, but the march was, in truth, a death march. Cruelly, much of it occurred in winter, and many succumbed to disease, exposure and malnutrition. The Cherokees who survived the previous day's march—and that night—to see the new dawn had to bury their dead along the roadside. Overall, ten to twenty people died every single day of the march. Though an accurate total is impossible to calculate, combining the dead from the camps, those who passed on the march itself and those who fell after their arrival due to the rigors of the journey, approximately four thousand Cherokees died.

Though "fortunate" is not a word that comes to mind when considering the history of the Cherokees, it is nevertheless not entirely inaccurate. Consider that many Native American tribes no longer exist. Exposed to diseases to which they had little resistance and facing relentless war against more technologically advanced weapons, not to mention the sheer number of European invaders, many Native American tribes became completely extinct. Whole peoples, as well as their cultures, myths, legends and languages, forever vanished. Yet the Cherokee people still survive, and according to the U.S. Census Bureau, today their total population throughout the United States numbers approximately 700,000. The principal people—while the fact of the tragedy perpetrated against them lingers—persevered.

CHAPTER 2

AT THE CROSSROADS

AN ACT to incorporate the village of Ringold, in the county of Walker, on parts of lots number one hundred and seventy and one hundred and seventy-one, and to appoint Commissioners for the same.

—*Georgia General Assembly, December 27, 1847*

At the midpoint of the nineteenth century, much of Europe was embroiled in the Crimean War, with the British, French, Sardinians and the flagging Ottoman Empire in an alliance against Russia. Few realized, however, that events were moving toward a much larger, and much more costly, European war. Otto von Bismarck, who some argue helped inadvertently lead Europe down that path, sat in the Landtag, the lower house of a newly formed Prussian legislature.

At this early point in his political career, Bismarck opposed the unification of Prussia with several other Germanic entities into a single power. But his opinion eventually changed, and he went on to lead that loose collection of principalities and cities to ultimate unification under a single German Empire.

In Asia, the Taiping Rebellion (a Chinese civil war that lasted until 1864) broke out and, at somewhere between ten to twenty million dead, dwarfed the causalities of the Civil War soon to break out in the United States. And Japan, the island nation isolated from Western influences that Marco Polo's contemporary Europeans found difficult to believe even existed—despite Polo's remarkable tales—remained much as it had been in the late 1200s,

when the famous traveler first heard stories of its wealth and grandeur from the Chinese. After Portuguese traders arrived in 1543, there was a brief period that lasted just under a century when Japan had contact and traded with the West. But in the 1630s, the shogunate forbade outside trade and shipbuilding and began persecuting any Japanese who had converted to Christianity. In the 1850s, at the initiative of the United States, this trend of isolation and persecution was about to change. U.S. Naval Officer Commodore Matthew Perry essentially forced a treaty upon the Japanese that opened their ports to U.S. trade. This treaty, and the events that followed, eventually led to the modernization of Japan and, ultimately, to Japanese imperial ambitions. The road to Pearl Harbor and the atomic age had been laid.

In the United States in 1850, California became the thirty-first state admitted to the Union, even as the clouds of dissolution of that Union—and war—ominously gathered over the nation. Also in that year, a disillusioned Whig from Illinois, having left behind politics and Washington, D.C., the year before, steadily worked at building his law practice again. But, as events would prove, Abraham Lincoln's political career was not yet over. The topic of slavery, which held the nation's attention in a chokehold, would soon lead him back to Washington and the nation to war. In Georgia, the 1850 census tallied the state's population at 906,185 people (the seventh largest in the nation), with over 380,000 of them African slaves. Of all the Southern states, only Virginia was more populous and had more men, women and children in bondage. This "peculiar institution" dominated both the economic and political landscape of the state and permeated its culture, as well. While less than 10 percent of the white population owned slaves, more than two-thirds of the state legislature were slaveholders—wealth necessarily led to power.

Ringgold, soon to become the county seat of a newly created Catoosa County, was merely a small settlement in 1850, practically as far north and as far west as one could travel and still remain in the state of Georgia. The census records for that year marked the first time that the United States recorded counts on two different schedules—one for free inhabitants and one for slave inhabitants (which did not list individual names, only the names of the owners). Ringgold claimed a total of 336 people, with 48 heads of family. Broken down, Ringgold (misspelled with only one *g* on the actual records) had 169 men (126 free, 43 slaves) and 167 women (126 free, 41 slaves) living in the town. Of the 15 slave owners in Ringgold, the majority of slaves were held by two farmers: David S. Anderson (with 32 slaves) and Robert F. Curry (with 21 slaves). The other residents of the town evidenced a variety of occupations: in addition to more farmers, there were merchants,

physicians, grocers, carpenters, mechanics, a minister, a saddler, a tavern keeper, a shoemaker, a teacher, a cabinetmaker, a tailor, a carriage maker, a wagon maker, a cooper, a brick mason and even a showman and a ventriloquist, among others.

A Small Stop Along the Old Federal Road

Early maps of northwest Georgia—while the territory remained in the possession of the Cherokees—mark a small town just to the west of the gap. At this point, the settlement had yet to be designated Ringgold and was instead known by a variety of names: Dogwood, Taylor's, Taylor's Gap, Taylor's Stand, Taylor's Station, Taylor's Crossroads or simply Crossroads.

The town sits along Chickamauga Creek, a tributary of the Tennessee River, and is nestled between Lookout Mountain and Taylor's Ridge. Its eventual growth and development were largely due to its position along the route of the Federal Road, one of two such roads linking Georgia to neighboring states. Mostly following a long-established Cherokee trading path, the portion of the Federal Road that would pass through Cherokee lands began in Athens and proceeded north until it forked in what is now Murray County. One portion continued north toward Knoxville and the other headed toward Chattanooga. The latter branch passed through Ringgold, where Richard Taylor's Inn and Tavern offered a respite from the burdens of nineteenth-century travel.

President James Monroe made use of the road and, purportedly, spent a night at Taylor's Inn. Traveling north through Georgia from Savannah, Augusta and Milledgeville (then the state capital), Monroe visited the Moravian mission at Spring Place and, continuing on into Crossroads via the Federal Road, stayed the night at Taylor's on May 26, 1819. He visited the Brainerd Mission the next day, only about ten miles north in Tennessee.

The road brought more and more settlers into Native American territory, and the numbers only increased after the Cherokees and Creeks vacated those lands. Ironically, the Treaty of Washington with the Creeks and the Treaty of Tellico with the Cherokees—agreements that granted the government the right to build roads through their lands—created the very paths used to help expel the Native Americans.

Despite the name, "Federal Road," Georgia and Tennessee built it. Construction started sometime around 1810, and for the most part, the federal government's role ended with securing the treaties from the

Native Americans. The overall goal of the project, however, originated in Washington as a way to improve travel and trade between the settlers in Georgia, Tennessee and Alabama, as well as to facilitate mail delivery.

There is no way to calculate how many travelers made use of the road or how many passed through Crossroads. From the Cherokees and Creeks who were forced out over its route to the settlers, soldiers and slaves in wagons, on horseback or on foot who followed them, the Federal Road was almost outdated before it was even completed. It operated for less than a quarter of a century before railroads began to render portions of the route obsolete. Maps drawn in the 1850s illustrate an incomplete route, denoting the deserted portions of the road. Still, enough of it survived so that, by the time of the Civil War, both Union and Confederate troops made use of the road. By the early 1900s, however, very little of the route was still in use. Even less of it is visible today, though modern roads traverse portions of the fading Federal Road route.

The Western and Atlantic Railroad

On December 21, 1836, the State of Georgia officially approved the construction of what was then called the State Line. The idea to create a link between the Chattahoochee River and the Tennessee River had been around since the early 1820s, but as originally conceptualized, that link was to be a canal. The impracticality of the plan, however—as well as the advent of rail lines—changed all that. The Baltimore and Ohio, the first railroad in the United States, began construction in 1828 and proved just how advantageous a rail line could be to a city. Soon, numerous other railroads linked the nation together.

Construction began on the Western and Atlantic in 1838, and when completed the line would link Athens, Augusta, Madison, Macon and Columbus to a preselected point just seven miles southeast of the Chattahoochee River. A small settlement, aptly named Terminus, grew up around that point. From there, the line proceeded north to the Tennessee River at Chattanooga. As more track stretched out from Terminus, the small settlement grew. In 1843, it was renamed Marthasville, and in 1845 it was renamed one last time, becoming Atlanta.

Progress on the railroad itself, however, was initially very slow. The construction, which later expanded southward from Chattanooga to link up with the progress already made northward from Atlanta, ultimately

Early History

took twelve years to complete. Completion of the northward portion up to Tunnel Hill occurred on October 31, 1849. The Chattanooga portion moving southward was almost finished, and on December 1, 1849, the first train passed through Crossroads (by then renamed Ringgold). A few months later, on May 9, 1850, the entire line was officially completed.

Ringgold, a warehouse town, became the busiest stop between Atlanta and Chattanooga, and its population soon soared to approximately fifteen hundred residents. The Ringgold Depot, built in 1849 out of sandstone (though portions were later replaced with limestone blocks to repair artillery damage during the Battle of Ringgold Gap), served repeated roles during the Civil War. It was the last stop passed by the Andrews Raiders, served as the anchor of Patrick Cleburne's line while defending the Confederate withdrawal and countless stores of supplies streamed through it on their way to Confederate forces from Atlanta (second only to Richmond in importance to the Southern war effort and the key transportation site of the Confederate war machine). By the time of its construction, Ringgold was a larger market even than neighboring Chattanooga. Its location, standing at the intersection

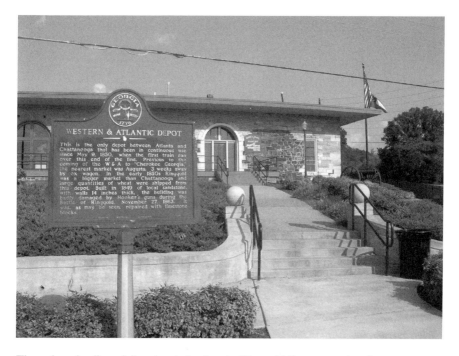

Throughout its silent vigil at the city's edge, the Ringgold Depot served as the gateway through which prosperity first came to Catoosa. *Photo by Jeff O'Bryant.*

of three major routes, briefly allowed the city to claim greater size than any other town between Augusta and Nashville. But this distinction was short-lived, as Cassville would soon outstrip Ringgold.

OLD STONE CHURCH

Nevertheless, progress continued and the community grew. Construction on Old Stone Church was finished in 1849, just outside of Ringgold on the Old Federal Road. Organized by a group of Scotch-Irish immigrants who moved to Georgia from Tennessee, this Presbyterian congregation held its first meeting on September 2, 1837. Members met in a one-room log cabin and christened themselves the Chickamauga Presbyterian Church. Reverend William Hall Johnston, who served as pastor from 1846 through 1856, oversaw the construction of the church. It took two years to build at a cost of $1,600.

During the Civil War, the church served as a hospital, tending to Confederates at one point and then Union troops. Bloodstains are still visible

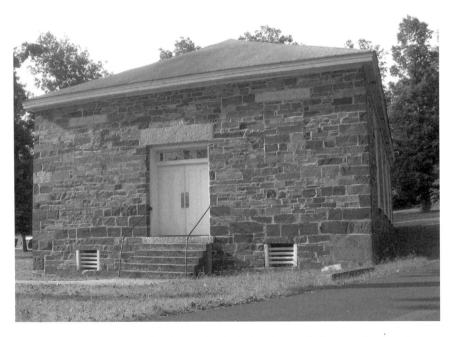

Old Stone Church, the first church organized within what would become Catoosa County, served as a hospital for Confederate, and then Union, soldiers. Their bloodstains are still visible on its wooden floors. *Photo by Jeff O'Bryant.*

on its floor. After the war, it passed through numerous congregations—first Presbyterians, then Methodists and Presbyterians, then just Methodists and, finally, Baptists.

In 1887, the first performance of the popular religious hymn "Leaning on the Everlasting Arms" occurred at the church. Anthony Johnson Showalter wrote the music and chorus, and Elisha A. Hoffman wrote the verses. Showalter was a composer, teacher and publisher, authoring several books on music theory and one on harmony and song composition. Singing schools throughout the South taught from his books. Hoffman was a prolific songwriter, composing over two thousand hymns in all. In addition to "Leaning on the Everlasting Arms," his most popular include "What a Wonderful Savior!," "Enough for Me," "Are You Washed in the Blood?," "No Other Friend Like Jesus," "I Must Tell Jesus" and "Is Your All on the Altar?"

Built from local stone—hence its name, Stone Church—it officially took that title in 1912 after the Chickamauga, Georgia Presbyterian church requested the right to use the name Chickamauga Presbyterian Church. Popularly known as Stone Church anyway, the members agreed.

New Name, New Rules and Regulations

In anticipation of the coming of the railroad and the hoped-for benefits that it would bring, the residents of Ringgold incorporated the town on December 18, 1847. The act by the Georgia General Assembly, which misspelled Ringgold with only one *g*, went on to name five commissioners: Michael Dickson, George W.H. Anderson, J.J. Johnson, William Buppord and D.S. Anderson. The 1850 census notes that all but one (Buppord) of these founding commissioners still remained in Ringgold at that time. Dickson was listed as a tavern keeper, Johnson and George W.H. Anderson as merchants (the latter of whom owned two slaves) and D.S. Anderson as a physician who owned thirty-two of the town's eighty-four slaves—more than any other resident of the town.

The commissioners were vested "with full powers to make such by-laws, rules and regulations, that may be necessary for the improvement and the internal police of said town: *Provided*, Such by-laws, rules and regulations shall not be repugnant to the Constitution and laws of this State." Many of the laws created by Ringgold's commissioners dealt with slave issues. There were various punishments for everything from disorderly conduct and public

drunkenness for the slaves themselves to fines and penalties for owners or other free residents, depending on the manner in which they employed slaves. It was also illegal for merchants to sell liquor to slaves or free persons of color without the permission of their master or employer. Other rules for free residents concerned everything from business practices to moral issues. A license to sell goods within the city limits cost between $5 to $25, public use of profanity or performing labor on the Sabbath cost the offender from $1 to $10 and owners of gambling establishments faced fines of $25 (or $100 for repeated offenses). The commissioners also frowned upon prostitution. Fines ranged from between $25 and $75, or offenders could be imprisoned (in some cases both punishments could be imposed) for keeping a "lewd house, or house of ill fame" or boarding a woman "after notice of her character has been given."

Commissioners, laws, business regulations—much was changing in the small village thanks to the recent incorporation. Perhaps the most obvious change it marked—as the incorporation most likely marks the point at which the town shed itself of the numerous designations by which it had hitherto been known—was the decision in favor of a single, official city name. The selection of Ringgold, in honor of the fallen Mexican War hero Samuel Ringgold, begs the question: why? Ringgold never stayed in the town or even passed through it. It is unlikely that he had ever even heard of it. Further, in December 1847, an entire year and a half had passed since Ringgold died. So why name the town after this seemingly obscure soldier killed in the Mexican War? The question seems an obvious one from the modern vantage point, but for Americans in the mid-1800s it was the choice of the name Ringgold that seemed obvious.

CHAPTER 3

LEGACY OF A FORGOTTEN HERO

But who the mournful tale shall tell, how gallant Ringgold fought and fell?

—*From "On to the Charge," a ballad inscribed to the memory of Major Samuel Ringgold by John H. Hewitt*

At one time, the name Major Samuel Ringgold far surpassed in fame those of such well-known figures as Ulysses S. Grant, Robert E. Lee, George McClellan, James Longstreet, George Meade, Ambrose Burnside, Braxton Bragg and Jefferson Davis. Unlike these famous Civil War leaders, Ringgold did not return from the conflict in which they all served under the same flag: the Mexican War.

The first officer to be killed in the war, during the conflict's opening battle at Palo Alto (near present-day Brownsville, Texas), Ringgold quickly became a national hero, boosting the morale of the army and capturing the imaginations of his fellow Americans. Soon immortalized in numerous songs, Ringgold is most famously honored in the fourth verse of "Maryland, My Maryland" ("With Ringgold's spirit for the fray"), in tribute to his personal bravery. Several engravings imagined the circumstances of his mortal wounding at Palo Alto, actors portrayed him on stage, writers eulogized his memory in poetic verse, speechmakers extolled his virtues to the public and city, town and county founders selected his name for their locales.

Ringgold was born on October 16, 1796, at Front Park, near Hagerstown, Maryland. He was the third of five children born to Maria Cadwalader

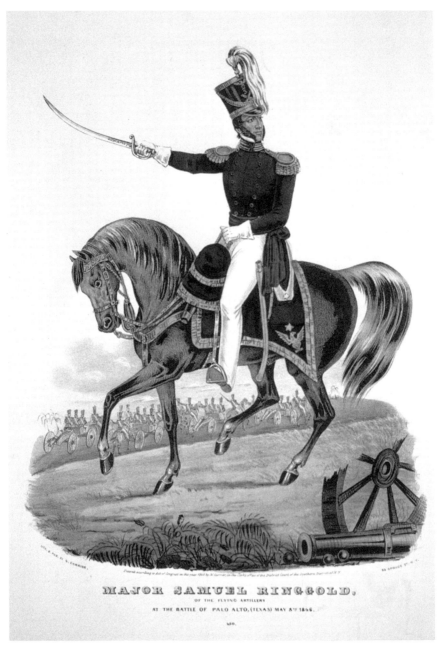

This hand-colored lithograph, published by N. Currier after Ringgold's death, is titled "Major Samuel Ringgold: of the flying artillery at the Battle of Palo Alto, (Texas) May 8th 1846" and features the nation's new hero in a courageous pose. *Courtesy of the Library of Congress, LC-USZC2-2803.*

Early History

(daughter of Revolutionary War General John Cadwalader) and Samuel Ringgold, a U.S. congressman from Maryland and owner of an extensive landed estate in Washington County, Maryland, known as Fountain Rock. His younger brother, Rear Admiral Cadwalader Ringgold, served with distinction in the U.S. Navy.

Ringgold attended West Point and graduated in 1818, fifth in his class out of twenty-three cadets. Commissioned a second lieutenant, he joined the Second U.S. Artillery and briefly served garrison duty at Fort Mifflin, Pennsylvania. He then served three years as aide to General Winfield Scott. In 1822, he received a promotion to first lieutenant while serving in the Third U.S. Artillery.

Though his death made him famous, Ringgold's true legacy lay in the artillery tactics he developed and the improvements he made to the technology itself. He began to hone his artillery skills while attending the Artillery School for Practice at Fort Monroe, Virginia. There he also joined the Freemasons, becoming a member of the now defunct Comfort Lodge #143 at Old Point Comfort in 1826.

After alternating between garrison and ordnance duty and then fighting in the Second Seminole War, where he was promoted to brevet major for bravery, Ringgold traveled overseas to observe European artillery techniques and technologies. Ringgold likely made this trip for another reason: to restore his health from sickness, possibly malaria, contracted in Florida. While in Europe, he studied at both the École Polytechnique in Paris and the Military Institution at Woolwich in England.

Upon Ringgold's return home in 1838, Joel Poinsett, secretary of war to President Martin Van Buren, ordered him to organize and equip a battery of light, or "flying," artillery:

> *Adjutant-General's Office,*
> *Washington, September 18th, 1838*
> *Sir: Having been selected by the Secretary of War to organize, equip, and command the first company of light artillery authorized by act of 1821, you will repair to Carlisle barracks and lose no time in proceeding to execute the views of the department. The number of horses necessary for the purpose being now in depot, will require your immediate attention. As the convenience of the general service will not, at this time, justify the ordering of your company to Carlisle, you will see by my requisitions on the colonels of the First and Second regiments of artillery of this date the measures which are, for the present, to be adopted for the formation of the proposed company. The ordnance, equipments, and all other supplies will*

be furnished in due time by the proper departments. You will forward to this office your requisitions for the approval of the Secretary of War.

Joining Ringgold were select members of his company from the Florida campaign, as well as officers from the First and Second Artillery. The latter were those deemed most capable in the science of artillery.

This was not the first attempt by the young United States to develop an effective light artillery unit. During Thomas Jefferson's presidency, at the order of Secretary of War Henry Dearborn, the army first tried in 1808. Little came of this effort. Later, as the War of 1812 approached, Colonel Moses Porter commanded another newly formed light artillery unit. This unit also made little progress and served, mostly due to a shortage of horses and equipment, as an infantry force. It disbanded in 1821.

Ringgold, therefore, had to build his unit from the ground up. Combining all he had learned into an efficient whole, his bronze guns, slung low between oversized wheels, proved much lighter and more mobile than regular artillery. He also improved efficiency by elevating the screw and the firing mechanism. Further, his gun crews, which usually rode on the limbers (the part of the carriage consisting of an axle, pole and two wheels), each received horses of their own, greatly enhancing their mobility and speed. Ringgold polished these technical improvements with drill, demanding both discipline and frequent, unrelenting training.

His dedication paid off. His men could unlimber and load their artillery in less than a minute, a remarkable speed given the standards of the day. Indeed, his innovations led to such an enhanced standard of polished performance that his superiors used a mounted four-gun battery he devised to impress both potential recruits and congressmen (who, of course, voted on military funding). Able to fire, move to a new location and fire again, all before the smoke from the last shot cleared, Ringgold's innovations riveted onlookers. Congress eventually approved three additional flying artillery batteries.

Ringgold was the undisputed authority on light artillery, but he was not the only one dedicated to its success. By the time the Mexican War broke out, there were five batteries of light artillery in the army. While all of them bore the marks of Ringgold's innovations, nobody was more determined than Lieutenant Braxton Bragg to match the major's standards. In fact, he spent so much time at drill and drove his men so hard that they almost mutinied, a portent of things to come for Bragg during the Civil War.

The methods and innovations with which Ringgold inspired others were not, however, the only military improvements he made. His research in

Europe also led him to rewrite the U.S. Army's artillery manual. The army adopted this manual, titled *Instructions for Field Artillery*, on March 6, 1845, and Ringgold received a promotion to the rank of major in acknowledgement of his military innovations. He developed the Ringgold military saddle, a saddle and bridle arrangement for both cavalry and artillery horses, at least parts of which survived in some form until 1885. He also made improvements to the percussion cannon lock, introducing a spring that drew the hammer sideways and backwards, greatly reducing the likelihood of the hammer being knocked from its position and disabling the gun. But his distinction as the "Father of Modern Artillery" is Ringgold's distinguished, if largely unknown, legacy.

Ringgold's improvements, however, remained untested. Field exercise, recruitment displays and impressing congressmen were all well and good, but actual success on the battlefield was quite another thing. Manifest Destiny, national pride and a Southern desire for the territorial expansion of slavery would give Ringgold the chance to prove his new techniques and technology.

RINGGOLD TESTED

After Mexico won its independence from Spain in 1821, it controlled all of the present-day states of the Southwestern United States. But the war left the newly formed country both weak and without funds. Its government was simply unable to effectively rule a large area so far north of its capital in Mexico City. It found itself in further difficulty when Mexican authorities allowed what they thought would be just a few hundred U.S. settlers to inhabit Texas. Far greater numbers actually settled the area than Mexico agreed to or even expected. Soon, the number of American inhabitants quickly grew to surpass the number of their host's own settlers.

The United States offered to buy Texas, but Mexico refused. Failing to perceive the potential implications of the attitudes of Texans—who became disenchanted with Mexico for a variety of reasons, not the least of which were a growing centralization of power in Mexico City and a lack of certain freedoms that settlers had been used to under the U.S. government—events rapidly deteriorated. After General Santa Anna's election as president in 1833, he soon abolished Mexico's 1824 Constitution and replaced it with one that gave him greater powers. Texas soon rebelled.

Mexican forces, led by Santa Anna, invaded Texas and won initial victories at the Alamo and Goliad. But Texas decisively defeated Santa Anna at the

Battle of San Jacinto and firmly established itself as an independent nation. Most Texans, however, wanted annexation by the United States. Yet Mexico, never having recognized the independence of Texas, warned that any such move by the U.S. government would lead to war. Despite both this threat and Whig opposition, Southern Democrats believed in Manifest Destiny, the idea that westward expansion was inevitable, and—most critical to their desire—sought to expand their slave empire. They tirelessly pushed for the admission of Texas into the Union and, on December 28, 1845, realized their ambition when James K. Polk signed into law the admittance of Texas as the twenty-eighth state.

Relations with Mexico deteriorated, and Polk sent forces under the command of Zachary Taylor to protect the new state. Samuel Ringgold and his "flying artillery" were part of this force. But Taylor, though he liked and even admired Ringgold, had a low opinion of field artillery. He strongly doubted that Ringgold's light artillery would prove effective. That opinion was about to change.

On May 8, U.S. forces numbering approximately twenty-three hundred men engaged a larger force of thirty-two hundred men under General Mariano Arista at Palo Alto. Early that morning, Arista had ordered his men to deploy into a strong position at Palo Alto Prairie in an effort to block the U.S. advance. Their line, a mile long, comprised infantry and artillery, with cavalry at either end. U.S. forces arrived at about noon. Assessing the situation, Taylor and his officers realized that a frontal assault with infantry was too hazardous and too unlikely to succeed to risk. Ringgold requested that Taylor allow him the chance to show what his artillery could do, but the general was reluctant. Ringgold had to press his case, nearly pleading with Taylor to give him and his men a chance. Taylor finally agreed.

Ringgold ordered his gunners to follow him at a full gallop toward Arista's forces. Once within range, they deployed their guns and fired, ripping into the enemy ranks and mowing down large numbers of the densely packed troops. When Arista attempted to redeploy his heavy cannons and target Ringgold and his men, the "flying artillery" unit simply moved, repositioning their guns, and continued to pour withering fire into the Mexican ranks.

Ringgold's gunners proved so successful that Taylor's infantry hardly saw any of the battle's action and sustained few losses. But among the battle's causalities was Ringgold himself. Late in the afternoon, a Mexican cannonball—artillery, ironically—tore through his thighs. Taylor's official report, a rather dry document and not sensationalized by the general, nevertheless offers some praise and provides a hint as to Ringgold's demeanor

Early History

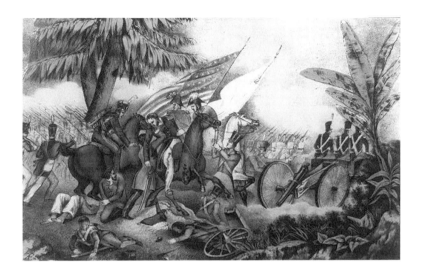

"The Death of Major Ringgold." Numerous images circulated around the United States after Ringgold's death, offering various (and sanitized) versions of his fate. *Courtesy of the Library of Congress, LC-USZ62-1268.*

during the battle: "The Major himself, while coolly directing the fire of his pieces, was struck by a cannon ball and mortally wounded." Despite his wound, Ringgold refused to leave the battlefield, ordering men who came to check on him to carry on with their duty, and he continued to give commands to his men. He is said to have exclaimed, "Don't stay with me; go ahead—you have work to do!"

Only when he was satisfied that the battle was won did he permit himself to be removed from the field. Taken to Point Isabel, Texas, Ringgold died there on May 11, 1846, three days after receiving his wound.

The Battle of Palo Alto was a complete victory for the United States. Mexican forces suffered 125 killed, 200 wounded and 26 captured compared to total American losses of 9 killed, 45 wounded and 2 captured. Arista withdrew his forces that night in retreat.

Ringgold's Legacy

For a time, Ringgold's name was familiar, even revered. In a speech before the Maryland Historical Society delivered on April 1, 1847, James Wynne,

MD, who witnessed the return of Ringgold's body back to his home state, claimed that businesses closed and thousands turned out to glimpse Ringgold's coffin and the "splendid military cavalcade, collected from all parts of the state, which accompanied his remains." He spoke in glowing terms of Ringgold's character, his dedication and the military improvements he devised. These innovations had not only been vindicated, but they also continued to prove themselves over and over again throughout the Mexican War, which the United States fought to a decisive victory in 1848. Soon, armies all over the world began incorporating Ringgold's artillery improvements into their own artillery units. In 1861, one of Ringgold's subordinates in Company C, Lieutenant Barry, used his knowledge from serving under Ringgold's command as chief of artillery during the formation of the Army of the Potomac.

Yet, while his innovations survived him, his star eventually dimmed in the minds of Americans, who soon forgot the name Ringgold. While it is true that both he and Taylor became nationally celebrated heroes (the first, in fact, since Andrew Jackson's success at the Battle of New Orleans in 1815), only Taylor's name found lasting recognition. The Civil War, coming just fifteen years after Ringgold's death and creating an entire pantheon of American heroes and legends all its own, would all but obliterate the memory of Ringgold from the minds of most Americans. No longer did founders consider the name Ringgold for their cities, towns or counties, as such names as Lincoln, Lee and Jackson were the new choices of preference.

Still, Americans would, albeit briefly, be reminded of Ringgold's name when, shortly before his death in 1885, former president U.S. Grant wrote that Ringgold was "an accomplished and brave artillery officer" as he recalled his early career in his popular and successful *Personal Memoirs*. It was nearly forty years after the Battle of Palo Alto, and Grant had been a young lieutenant when he saw action that day with Ringgold. Readers, of course, were most eager for the portion of the memoirs that contained Grant's Civil War tales. And they were not disappointed.

Yet, perhaps tellingly, when Grant recounts his role during the Civil War, he makes no special mention of the "Father of Modern Artillery" during his time in Ringgold, Georgia, in late 1863. His only descriptive words concerning the town itself are sparse: "Ringgold is in a valley in the mountains, situated between East Chickamauga Creek and Taylor's Ridge, and about twenty miles south-east from Chattanooga." Other than matters of a military nature, that was all he wrote.

Grant was the commander of an invading force, occupying a town bearing the name of a fellow soldier with whom he had served and whom

Early History

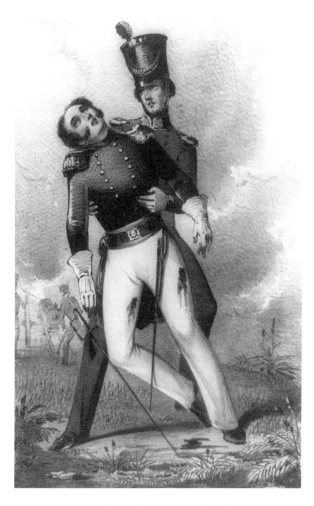

Another interpretation of the events at Palo Alto, entitled "The death of the gallant Major Ringgold." *Courtesy of the Library of Congress, LC-USZ62-7366.*

he respected. Did he not make the connection? This is unlikely. And what of Bragg, who not only served alongside Ringgold, but also eventually even took over command of the major's unit after Ringgold died? He left no comments behind regarding any connection he may have made to the major and the Battle of Ringgold Gap.

Perhaps a town so named was of little interest to either man considering that former living comrades in arms were now fighting; friends had turned into enemies and were killing each other in large numbers. Or perhaps,

through their experiences of the carnage of war, neither wished to dwell upon any more lives cut short by battle. Especially a life like Ringgold's, a soldier who, had he not died after Palo Alto, might have gone on to be remembered like Robert E. Lee, James Longstreet, Jefferson Davis and even Grant and Bragg are remembered today.

Such is the caprice of history, and Ringgold's story continues to grow ever dimmer. The Mexican War, overshadowed by the Civil War and wars within living memory, remains unpopular in the eyes of many Americans as a war of aggression by a stronger nation against a weaker one. Abraham Lincoln spoke out against it while serving as a representative in the U.S. House, and Grant, too, condemned the war despite his participation in it. At the time, however, many Americans were proud of the nation's military accomplishments, as the honor they paid to Ringgold attests.

Of those places named for Ringgold, one has all but vanished. Fort Ringgold, built after the Mexican War ended, operated for nearly a century as a sentry post overlooking the Rio Grande and Rio Grande City, Texas, but it closed in 1944. Ringgold County, Iowa, however, still bears his name, as does Ringgold Township in Pennsylvania. And there are cities and towns of Ringgold in Louisiana, Virginia and, of course, Georgia. Still, these last, most obvious tributes to his name hold majorities who are unaware of Samuel Ringgold's impact on not only military history, but U.S. history as well. His victory at Palo Alto only served to corroborate his methods as, time and again, they demonstrated their worth in later battles of the war. Though certainly not singlehandedly, Ringgold unquestionably aided the United States in achieving victory against Mexico, which lost approximately half of its territory. This newly won land would eventually contain the states of Arizona, California, Nevada, New Mexico, Texas and Utah. Portions of the future states of Colorado, Kansas, Oklahoma and Wyoming also originated from the lands Ringgold helped win. In all, the territory gained, in square miles, is second only to Thomas Jefferson's Louisiana Purchase as the largest expansion of American territory in U.S. history.

America abounds with memorials, monuments, statues and protected battlefields, yet Palo Alto did not become a National Historic Site until relatively recently (November 10, 1978). As of 1992, the site's primary purpose is preservation and to turn the battlefield into a "place of binational exchange and understanding," reflecting the perspectives of both the United States and Mexico. Yet no monument stands to tell the tale of how the gallant Ringgold fought and fell.

CHAPTER 4

A NEW COUNTY IN THE HILLS OF NORTHWEST GEORGIA

Be it enacted by the Senate and House of Representatives of the State of Georgia in General Assembly met, and it is hereby enacted by the authority of the same, That from and immediately after the passage of this act, the new County shall be laid out from the counties of Walker and Whitfield...Be it further enacted by the authority aforesaid, That the new county described in the first Section of this Act shall be known by the name of Catoosa.

—*Act of the Georgia General Assembly, Law Number 218, 1853*

Though the Western and Atlantic Railroad made Ringgold a boomtown, the traveler of short distances from his farm to town or from his home to his neighbor's had not changed much since the creation of the wheel. Travel by foot, horse or wagon had not been completely, or even mostly, replaced by trains, and practical, affordable automobiles were still over a half century away. In a move acknowledging both this fact and the growing population of the area, the Georgia state legislature accepted a proposal from state senator Michael Dickson to carve out 162 square miles from Walker and Whitfield Counties to form the new county of Catoosa. The primary impetus of this move centered on the need to lessen the time citizens had to travel in order to attend court and take care of other business with their local government.

Dickson, one of the first five commissioners of the city of Ringgold, was the son of Thomas Dickson of England and was born August 31, 1811, in South Carolina. He came to Ringgold (then Crossroads) sometime between 1840 and 1844. Previously a resident of Lafayette, Georgia, and one of the founding members of that town, he was a member of the Georgia state

A Brief History of Catoosa County

legislature. In addition to introducing the bill that created Catoosa County, it is likely that he also selected Ringgold as the county seat, officially designated so on March 16, 1854. He owned considerable landholdings, as well as a saloon in Ringgold, and he was active in local politics. Additionally, he was a state senator, and from 1858 to 1859 he served as a county ordinary. He died on January 30, 1882, and lies buried alongside his wife, Sarah Hinton (May 19, 1816, to December 17, 1881) in the now abandoned Dickson Cemetery on Scruggs Road near the Georgia-Tennessee line.

Christened Catoosa

The official creation of Georgia's one-hundredth county occurred on December 5, 1853, as the state legislature voted to approve the creation of Catoosa. The new county took its name from Catoosa Springs, purchased from William Murray by two grocer merchants from Augusta, Hickman and Battey, and a doctor, McDonald, from Macon. Their influence helped

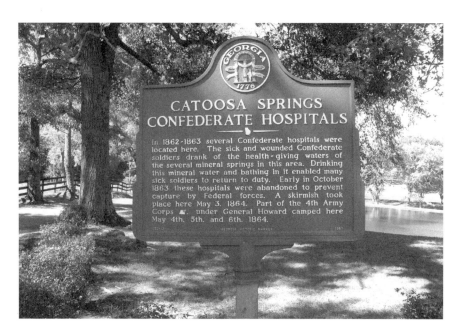

The Cherokees made the springs their home long before vacationers, health seekers and soldiers gathered there. The waters, like the county named after them, bear the Cherokee name of "gatusi" or "gadusi," which the Europeans converted into "Catoosa." *Photo by Jeff O'Bryant.*

secure the passage of the act, and their ownership of the springs led to the selection of Catoosa as the county's name.

These springs derive their name from the Cherokee word "gatusi," or "gadusi," and offer multiple possible meanings: "hill," "on the hill," "high point," "small mountain," "up into the hills" or, perhaps, a combination of the words "gatu gitse," meaning "new settlement." Some sources claim that Catoosa is the name of a chief who lived near the springs. No evidence exists to support this theory, however, and if there is a grain of truth to the claim, it likely means that the name refers to a chief *from* the springs—in much the same way that medieval English names (later to become surnames) referred to locations or professions.

The Cherokees who eventually settled the area held that the springs' waters had healing properties, and settlers, believing this claim, streamed into the area even before the removal. They hoped to find relief for their afflictions, which ranged from malaria and yellow fever to arthritis and dysentery. After the removal, Catoosa Springs became a summer resort, attracting mostly wealthy Southerners. For just two dollars per day (with modest discounts for weekly, monthly or seasonal stays), visitors had their choice between two hotels or numerous cottages. In addition to the supposedly healing powers of the water, visitors could enjoy fine dining, music (from a brass band) and even bowling in one of the hotels. And once the Western and Atlantic began operating, business boomed. A horse and buggy picked up visitors from the depot and took them on a twenty-minute trip along the Federal Road to the springs.

Catoosa Springs served as a Confederate hospital complex during the Civil War, as Confederate soldiers serving in the Chattanooga campaigns replaced the usual visitors. Operating from 1862 to 1863, the hospitals located at the springs totaled about five hundred beds and primarily served soldiers suffering from dysentery and other similar ailments. Caring for soldiers coping with disease was a serious challenge during the war—illnesses claimed more than double the number of lives than were lost on the battlefield.

As the number of patients grew, doctors commandeered hotels and cottages, as well as nearby churches, to hold the growing number of sick and wounded. They also petitioned for help from Dr. Samuel Hollingsworth "S.H." Stout. Stout, who was made medical superintendent of General Braxton Bragg's army in 1862 and appointed medical director of hospitals for the Army of Tennessee in 1863, had to deal with the same situation suffered by the commanders in the field: shortages of supplies. As conditions

worsened and the hospitals became more crowded, the subject was rendered pointless in October 1863, when Confederate forces had to abandon the springs and Union troops moved into north Georgia.

A small skirmish took place at the springs on May 3, 1864. Afterward, Union forces camped there, awaiting orders from General William T. Sherman. Henry M. Davidson, of the First Regiment of Ohio Volunteer Light Artillery, was complimentary of the springs in his later account of the history of his unit but not very generous to its patrons: "Catoosa Springs are situated in a beautiful valley surrounded by a series of commanding hills…In peaceable times it was a place of considerable note, where idle, worthless nabobs took refuge while undergoing medical treatment." After three days of partaking of the springs' waters themselves, Union troops moved out on May 6 toward Tunnel Hill. No indications remain that a Confederate hospital once stood at the springs, though there are earthen mounds that suggest soldiers are buried there.

After the soldiers departed and the war ended, Catoosa Springs again became a summer resort, attracting approximately three thousand visitors a year. In May 1872, the springs reportedly offered thirty varieties of mineral water, and small pavilions covered each spring.

On May 10, 1872, the *Weekly Catoosa Courier* ran an ad singing the praises of the springs:

> *Catoosa Springs The Wonderful Fountains of Health and Pleasure! The Brightest spot in the Sunny South. Are located in the Piedmont Region of Georgia, twenty-five miles South-east of Chattanooga, Tenn., and within two miles of the Western & Atlantic Railroad. These springs, Fifty-two in number, embrace every variety of Mineral Water found in the famous mountains of Virginia…Hotel and Cottage Buildings are in thorough condition, newly painted, and furnished with entirely new appointments. The Table will be first-class in every particular. A magnificent Ball-Room one hundred by thirty feet, and elegantly-fitted Parlors. Billiard and Bar-Room seventy-five feet long, and a spacious Bowling Saloon. Direct Telegraphic and Postal Communications. The buildings and grounds will be brilliantly illuminated with Gas, and every attraction will be afforded the visitors to Catoosa Springs.*

This newspaper, published in Ringgold, cost just $2.00 for an annual subscription (a six-month subscription cost $1.50). It also featured the railroad schedule by which visitors to the springs would arrive and residents could schedule their own travel plans:

Early History

Train #1, From Atlanta 5.03 AM
Train #2, From Chattanooga, 6.44 PM
Train #3, from Atlanta 2.36 PM
Train #4, From Chattanooga, 9.42 AM

But the local paper was not the only advertisement that hailed the springs. They also received favorable attention in mineral water guidebooks. In 1899, one such account of the springs noted:

> *The hotel and cottages at the springs have room for 600 guests, and are supplied with all modern conveniences. The climate is bracing and invigorating, even in the summer months; in winter it is temperate, and the weather is not subject to sudden changes of temperature. The springs are fifty-two in number, situated within an area of two acres. It is not unusual to find quite different properties even among springs only a few feet apart. Most of them are quite strongly mineralized. The ten principal ones are as follows: The "All-healing," the "Red Sweet," the "Cosmetic," the "Chalybeate," the "Magnesia," the "Congress," the "Alum," the "Black Sulphur," the "White Sulphur," and the "Buffalo."*

After a lengthy list of the ingredients of each spring, the piece concludes by claiming that the springs

> *are perennial, the most severe and persistent droughts causing no perceptible difference in the rate of their flow. The waters are recommended for stomach, kidney, and bowel disorders, and for debility. The "All-Healing" Spring is used for local troubles. The waters are shipped on order in bottles or barrels to any part of the country.*

Local legend held that one of the springs, the so-called "beauty spring," would give those who imbibe its water fairer skin. The rumor spread that the waters of this spring contained arsenic that would kill red blood cells and whiten skin.

The larger of the two hotels burned down sometime in the 1920s, and, slowly, visitation to the springs declined. Throughout the 1930s and 1940s, the spring served primarily as a site for community gatherings. Today, only six springs remain active, with one each producing a different mineral water: yellow, black, white, soda, buffalo and sulfur.

Of course, Catoosa Springs were not the only springs that dotted the county. Cherokee Springs, though not as large a draw as Catoosa Springs,

A Brief History of Catoosa County

welcomed summer visitors and also hosted a Confederate hospital during the Civil War. Other sources of water that early settlers made use of included Yates Springs, Poplar Springs, Newnan Springs, Cloud Springs, Blue Springs and Beaumont Springs, among others. Many current communities that originally developed around these sources of water or roads that pass near them still bear the names of their respective springs.

A Short Prosperity Before Secession

After a brief outbreak of cholera in the county's first year, the future appeared bright. The county completed its first courthouse in 1856, a two-story brick building that, at the request of local Masonic Lodge members seeking a meeting hall, had a third story added shortly thereafter. Purportedly, this saved the entire structure from destruction at the hands of General William T. Sherman's men, as Sherman ordered the fire that had just been started there extinguished when he learned that a Masonic hall made up the top portion of the courthouse. Sherman's name, however, does not appear in the

Completed on September 3, 1855, the Catoosa County Court House cost $6,845 to build (the lowest bid received for the job) and was erected on land donated by W.B.W. Dent. *Courtesy of the Catoosa County Historical Society.*

Early History

Freemason's own listing of famous members. While this does not necessarily make the story false, it nevertheless renders it questionable. The courthouse itself remained in use until 1939.

The 1860 census noted 2,410 males, 2,310 females, 358 slaves and 4 freedmen living in Catoosa County, for a total of 5,082 inhabitants. But the year 1860 would be the last time the category of "slave" would appear on a U.S. census. The new county enjoyed barely seven years of growth and prosperity before the nation began the fight over the final answer to the question of slavery in the United States.

Abraham Lincoln's election to president in 1860 proved to be the proverbial straw that broke the camel's back. Many Southerners were so opposed to Lincoln that his name did not even appear on the ballots in nine Southern states, Georgia included. Those among the Catoosa County males qualified to vote (as women, slaves and freedmen could not vote) had to choose between Stephen A. Douglas, John Breckinridge and John Bell. Breckinridge carried the state, but Lincoln, with the far greater population of the North behind him, carried the election with 1,865,908 ballots cast in his favor, giving him the necessary 180 electoral votes.

South Carolina became the first state to secede from the Union when, on December 20, 1860, the 169 delegates to its convention voted unanimously to leave the Union. Georgia was not as united. On January 19, 1860, delegates met at the state capitol in Milledgeville and voted 208 in favor of secession and 89 against. The vote, held at two o'clock in the afternoon, made Georgia the fifth state to secede. The ordinance read:

> *We, the people of the State of Georgia, in Convention assembled, do declare and ordain, and it is hereby declared and ordained:*
>
> *That the ordinance adopted by the people of the State of Georgia in Convention on the second day of January in the year of our Lord seventeen hundred and eight-eight, whereby the Constitution of the United States of America was assented to, ratified and adopted; and also all acts and parts of acts of the General Assembly of this State ratifying and adopting amendments of the said Constitution are hereby repealed, rescinded and abrogated.*
>
> *We do further declare and ordain, That the Union now subsisting between the State of Georgia and other States, under the name of the "United States of America," is hereby dissolved, and that the State of Georgia is in full possession and exercise of all those rights of sovereignty which belong and appertain to a free and independent State.*

Ordinance of Secession. Though not unanimous, the momentum of secession swept through Georgia and took most of its citizens along with it. Catoosa's two delegates split—Joseph T. McConnell voted in favor of secession, and Presley Yates abstained from voting in protest against leaving the Union. *Courtesy of the Hargarett Rare Book and Manuscript Library at the University of Georgia.*

Catoosa County was split, with one of its two delegates (Joseph T. McConnell) ultimately voting for, and the other (Presley Yates) abstaining in protest against, the ordinance.

McConnell, a Ringgold attorney, served from 1855 to 1856 as Catoosa's first member to the state legislature. When the Civil War broke out, he helped raise a company of soldiers. According to the Roster of Field, Staff, and Band of the Thirty-ninth Regiment, Georgia Volunteer Infantry Army of Tennessee, CSA, McConnell was elected first lieutenant of Company G, First Regiment, First Brigade, Georgia State Troops, on October 8, 1861, but soon thereafter he resigned (on December 11, 1861). The following year, the Thirty-ninth Regiment, Georgia Infantry, elected him colonel. He died on December 1, 1863, from wounds received at Missionary Ridge on November 25, 1863.

Yates, born in Wilkes County, North Carolina, in 1806, came to Catoosa County sometime before March 1856. He received a grant of 160 acres near Wood Station in Catoosa County and eventually increased his holdings to 5,000 acres. Yates Spring still bears his name. Sometime after his arrival, he married Rachel Thedford, who bore him eleven children. Susie Blaylock McDaniel, in her *Official History of Catoosa County, Georgia*, relates a story that Yates was "taken out by the Yankees and shot and left for dead." Apparently, the soldiers shot him through the eye, but he survived. This seems particularly ironic given that Yates voted against secession. He died in 1878.

Georgia was one of the wealthiest of the Southern states, possessing more railroad track than any of its sister slave states. It had also industrialized, at least more so than its Southern sisters. On January 21, 1861, the *Charleston Mercury*, in response to Georgia's secession from the Union, proclaimed "All hail to Georgia, the Empire State of the South," in rapture at the decision. The Confederacy had little hope of winning a war against the Union, but without Georgia, the South had practically no hope at all.

Celebrations erupted across Georgia as the news spread from Milledgeville. The cries of those who wished to remain loyal to the Union, or who called for further compromise, received no attention. Catoosa fulfilled its part in the preparations for the coming war and ultimately provided the new Confederacy with six companies of infantry and one of cavalry.

PART II

THE CIVIL WAR AND ITS AFTERMATH

CHAPTER 5

THE ANDREWS RAIDERS

Resolved by the Senate and House of Representatives of the United States of America in Congress assembled, That the President of the United States be, and he is hereby, authorized to cause two thousand "medals of honor" to be prepared with suitable emblematic devices, and to direct that the same be presented, in the name of the Congress, to such non-commissioned officers and privates as shall most distinguish themselves by their gallantry in action, and other soldier-like qualities, during the present insurrection [Civil War].

*—Portion of Senate Joint Resolution No 82,
signed by President Abraham Lincoln on July 14, 1862*

A continuation of the struggle for the promise for which so many suffered and died in the Revolutionary generation, the Civil War proved the most costly war in America's attempt to live up to the principles set down by the Founding Fathers. Fought from 1861 to 1865, over 3 million men (and a handful of women disguised as men) fought in the war. Approximately 600,000 of them—20 percent of the combatants and a full 2 percent of the population overall—died.

The chain of events leading to the war can be traced back to the creation of the United States as a nation that allowed slavery to continue, even after fighting a war dedicated to securing its own liberty. This single issue dominated the politics of the young nation and led to numerous successive events that edged the country ever closer to conflict. Even while devising the Constitution, debaters argued over how to count slaves toward

determining the number of representatives for each state. The three-fifths-clause compromise, counting slaves as less than a full person toward this determination, would give Southerners disproportionate sway in Congress in the coming years. The Constitutional Convention also approved a twenty-year extension of the African slave trade.

There were numerous other contributing factors to disunion and war: the Missouri Compromise of 1820, the new lands gained in 1848 by the success of the United States in the Mexican War, the Great Compromise of 1850, the publication of Harriet Beecher Stowe's *Uncle Tom's Cabin* in 1852, the Kansas-Nebraska Act of 1854, the Dred Scott decision in 1857, John Brown's raid on Harpers Ferry in 1859 and, finally, the election of Abraham Lincoln in 1860. Five months later, at four thirty in the morning on April 14, 1861, the war began as Southern forces opened fire on Fort Sumter in Charleston Harbor.

Early in the war, Catoosa County remained untouched by combat. County residents—totaling 5,080 according to the 1860 census, 710 of whom were slaves—who did not go off to fight would not face the destructive force of armies for almost two and a half years. But the county's plentiful water supplies at Catoosa and Cherokee Springs, as well as the Western and Atlantic Railroad line—which allowed for the quick transport of wounded soldiers—made Catoosa a practical choice in caring for the sick and the wounded. In Ringgold, hospitals were set up in the then new courthouse, the Craven House and two other unknown locations. The hospitals at Catoosa and Cherokee Springs, having easier access to water, were the largest in the county. Overall, the entire area could accommodate almost 2,500 soldiers.

Actual combat did not reach Catoosa County until 1863. The resulting devastation from both the Union and Confederate presence, to say nothing of the actual combat in the area, prompted the Georgia General Assembly to action. In the November-December session of 1863, the state passed "An Act for the relief of the people in certain counties therein mentioned, and for other purposes." Catoosa was among sixteen counties named to receive aid from the state. Each county in need received several thousand bushels of corn; eight thousand were set aside for Catoosa. But the language of the act hinted at more than just the condition of northwest Georgia:

> *WHEREAS, Owing to the depredations of the enemy, and the presence and necessities of our own army foraging upon the country, and also the extreme drought* [sic] *and early frost, the people of Northern Georgia are in great need of breadstuffs; and whereas, nearly the entire laboring population of*

The Civil War and Its Aftermath

said section is now in the army, and the people must inevitably suffer unless aided by the generosity of the State.

In 1862, the devastation of war was far away from Catoosa. Union troops, however, unexpectedly arrived in Ringgold that spring, and, just as unexpectedly, they were not pushing south as invaders but headed north as Raiders.

THE RAID

At about 5:00 a.m. on April 12, 1862, twenty men boarded a fifty-seven-ton locomotive, the General, at Marietta, Georgia. Earlier that morning—and in small groups so as not to arouse suspicions—they purchased tickets to various points up the line. The General's final destination that day was Chattanooga, and the tall, gray-eyed leader of the group intended to see to it that the engine reached its destination. But James J. Andrews nevertheless had his own schedule to keep, and it did not match that of the General's conductor, William Allen Fuller.

Andrews, a spy, smuggler and scout, conceived a plan to steal a train and drive it from Atlanta to Chattanooga. En route, he planned to burn bridges, destroy telegraph lines, dynamite Tunnel Hill and tear up the rail lines of the Western and Atlantic Railroad—the vital supply line that provisioned the Confederates in Chattanooga. Major General Ormsby M. Mitchel approved the plan; if successful, it would sever the link between Atlanta and Confederate troops in Tennessee.

A similar plan conceived by Andrews failed earlier that year when the engineer did not show up at the rendezvous point. This time, Andrews took no chances. He had three engineers: William Knight, Wilson Brown and John Wilson, as well as nineteen other volunteers, all from Ohio infantry regiments. He also had, like himself, one civilian, Samuel Llewellyn. Of this force, two failed to make it to Marietta (joining Confederate forces in Jasper, Tennessee, to avoid suspicion), and two others overslept that morning.

After leaving Marietta, the General made its way along the eight miles of track to Big Shanty (now Kennesaw). There, the General stopped, and the passengers and crew were allowed a twenty-minute breakfast. The Raiders remained behind, waited and then stealthily uncoupled all but the tender (which carried the train's fuel and water) and three empty boxcars. Knight took the throttle and, at Andrews's command, the

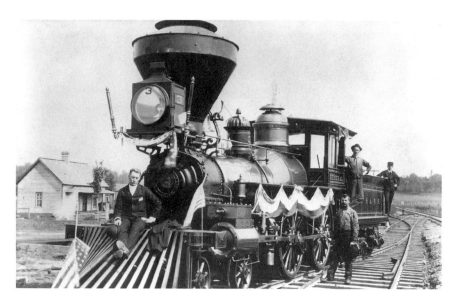

After an eighty-seven-mile chase, the General finally ran out of steam just north of the Ringgold Depot. This photo depicts the General after later restoration work. *Courtesy of Southern Museum Archives and Library, from the collection of Edith Knox.*

Raiders who remained outside the train scrambled into the last empty boxcar as Andrews leapt aboard and signed for Knight to go. The "Great Locomotive Chase" had begun.

The selection of Big Shanty as the hijack point was no accident: it had no telegraph. Andrews and his men, therefore, had time to destroy telegraph lines as they proceeded northward before anyone could make it back to Marietta and send a warning ahead of them. Pursuit, however, was instant and determined. William Fuller, the conductor, and Jeff Cain, who should have been at the General's throttle as it left Big Shanty, immediately began the pursuit on foot, running after the locomotive. Anthony Murphy, an Irish foreman on his way to pick up a part at Allatoona Pass, paused only long enough to send someone back to Marietta with word of the theft. Though Cain eventually abandoned the chase, Fuller and Murphy persisted. They soon procured a handcar and then the Yonah, a short-line locomotive. At Kingston, Fuller took the William R. Smith, a mail train. Two miles south of Adairsville, Fuller and Murphy had to abandon the William R. Smith, as the Raiders had destroyed a portion of the track. Taking up the pursuit again on foot, they arrived sometime later at Adairsville. There, Fuller took command of the southbound locomotive Texas (the General's sister train), running it in reverse in pursuit.

Time was running out for Andrews and his men. They had dropped railroad ties, torn up the track, cut a flaming boxcar loose in hopes of burning the Oostanaula Bridge and cut telegraph lines—yet still their pursuers were drawing nearer. Low on fuel and water, the General steamed past the Ringgold Depot just before 1:00 p.m. A few minutes later, the engine ran out of steam and came to a stop about two miles north of the depot. After seven hours, and over the course of eighty-seven miles, their mission ended in failure. Now they turned to the task of saving their own lives.

The Raid's Aftermath

Andrews and his men fanned out into the countryside in hopes of escape. They moved westward for two reasons: one, this direction led to the nearest Union troop encampment and two, they hoped the mountainous terrain would slow pursuing cavalry units. But they were unable to elude the large manhunt organized to track them down—all were captured within twelve days, even the two who overslept and were left behind.

Andrews, imprisoned and tried in Chattanooga, escaped. But his freedom did not last long. Recaptured and sent to Atlanta, he was hanged on June 7, 1862. Seven more of the Raiders died on the scaffold in Atlanta on June 18. Of the remaining sixteen, eight escaped and successfully made it back to Union lines. The other eight, eventually exchanged for captured Confederate soldiers, also survived.

While it is true that the Andrews Raid accomplished no significant military objective—the damaged rails and the cut telegraph lines proved quick to repair—it did give the North a collection of popular heroes. It proved to be the only train chase of the war and, similar to modern action films that almost inevitably have some sort of chase scene, it captured the country's imagination. All of the Raiders, except for Andrews and Campbell (as civilians, they did not qualify to receive the distinction), received the Medal of Honor. The Raider Jacob Parrott was the medal's very first recipient.

Fuller, who proved a dogged adversary, received recognition for his determined pursuit of the General. Honored by the Georgia General Assembly, Governor Joseph E. Brown commissioned Fuller to two consecutive six-month terms as a captain in the Independent State Railroad Guards.

The raid has also captured the imaginations of later generations. Hollywood produced two films based on the chase. Both are historically inaccurate but, nevertheless, ultimately proved popular. *The General*, a 1927 silent comedy,

A Brief History of Catoosa County

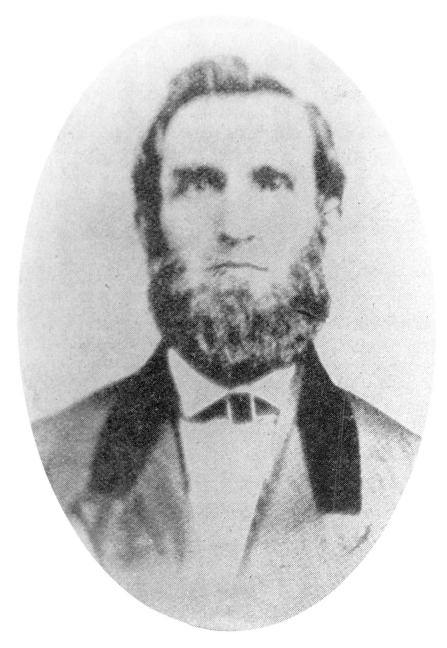

Union spy James Andrews conceived a plan to wreak havoc on the Confederate supply line from Atlanta to Chattanooga. Though a failure from a military standpoint, the Raiders became heroes in the North and were the first recipients of the newly created Medal of Honor. *Courtesy of Southern Museum Archives and Library, from the Southern Museum's Archive and Library Collection.*

The Civil War and Its Aftermath

A dogged pursuer of Andrews, William Fuller chased the General on foot, by handcar, by train and eventually commandeered the Texas, running the southbound train in reverse after the Raiders. *Courtesy of Southern Museum Archives and Library, from the Southern Museum's Archive and Library Collection.*

featured the legendary silent film star Buster Keaton. Initial reviews claimed that the picture was a disaster, but later generations of silent film fans and critics disagree and cite the film as not only Keaton's masterpiece, but also one of the greatest of all the silent pictures. In 1956, Disney released *The Great Locomotive Chase* starring Fess Parker (of Davy Crockett fame).

The General almost made it into pictures itself—and not just any movie. Were it not for the expense of the trip, which was deemed too costly, the General would have appeared in *Gone with the Wind* as part of the backdrop to the railroad yard scenes in Atlanta.

The General survives to this day. It narrowly escaped destruction when John Bell Hood ordered the supply depot in Atlanta destroyed, only to be captured (this time successfully) by Union troops. It remained in Federal hands until the end of the war. The General went on to give several more years of service before its history caught up with it. After displays at the New York World's Fair, Civil War Centennial celebrations and Chattanooga's Union Depot (from where it was "stolen" yet again), the General finally ended its travels where its most famous trip began—at Kennesaw, where it is on permanent display at the Southern Museum of Civil War and Locomotive History.

The monument that stands at the closing end of the General's now legendary journey, roughly two miles north of the Ringgold Depot, is, ironically, from the Kennesaw Marble Company of Marietta, Georgia. It stands as the only local reminder of the Great Locomotive Chase.

CHAPTER 6

CHICKAMAUGA

On my way I met General Wood, who confirmed me in the opinion that the troops advancing upon us were the enemy, although we were not then aware of the disaster to the right and center of our army.

—*From the report of Major General George H. Thomas to Brigadier General James A. Garfield*

The Battle of Chickamauga ranks second only to Gettysburg as the bloodiest of the Civil War. Approximately fifty-eight thousand Federal troops under the command of William S. Rosecrans and sixty-eight thousand Confederates under the command of Braxton Bragg furiously fought each other on September 19–20, 1963. Casualties were high. Over thirty-four thousand men (approximately sixteen thousand Union and eighteen thousand Confederates) died, suffered wounds or were captured.

Though it proved to be the last major battle of the war in which the Confederates enjoyed a victory, the triumph was rendered hollow as Bragg failed to follow up his success, missing his opportunity to strike a decisive blow. Instead, his men pursued the Union soldiers, who fell back into Chattanooga and, rather than giving battle, took up positions on Missionary Ridge and Lookout Mountain and in Chattanooga Valley.

Today, of the 5,382.2 acres that compose the Chickamauga Battlefield administered by the National Park Service, 3,830 are within Catoosa County. As the second largest battle ever fought in the Western Hemisphere, Catoosa's population briefly increased twenty-five fold before the soldiers on both sides poured back into Tennessee. But the danger was far from over. To

successfully contain the Federal army within Chattanooga, much less outright defeat it after Bragg lost his chance in the aftermath of Chickamauga, would prove precarious. The prize of Atlanta was within reach of the Union if its troops could successfully push the Confederates out of Tennessee and into Georgia. That accomplished, the first town in their path was Ringgold.

The Prelude and First Day of Battle

William Starke Rosecrans commanded the Army of the Cumberland. He was born in Kingston, Ohio, the great-grandson of Stephen Hopkins, a signer of the Declaration of Independence. He was a thoughtful youth, and his parents provided him with a stable, nurturing home life. He graduated fifth in his class from the U.S. Military Academy at West Point in 1842 and went on to serve as an engineer, and eventually as an instructor, there. He later returned to civilian life and ran a successful coal-mining business, but when the war broke out in 1861, he rejoined the U.S. Army. Before Chickamauga, he was in command at the Battles of Rich Mountain and Luka, the Second Battle of Corinth, the Battle of Stones River and then in the Tullahoma Campaign. Honest to a fault, Rosecrans found it difficult to hide his opinions of his superior officers. But the men serving beneath him admired and respected him. He was also overly excitable in battle (which led him to stutter) and overly controlling as well—he tended to obsess over details better left to his subordinates. Most critically, after achieving victory on the battlefield he often passed up possible opportunities for decisive strikes by failing to pursue the enemy (not an uncommon trait among certain Union generals).

Rosencrans's opponent at Chickamauga was Braxton Bragg, commander of the Army of Tennessee. In many respects, the two men seemed to be an equal match. Bragg also graduated fifth in his class at West Point (class of 1837), was quarrelsome with both superiors and subordinates and often failed to follow up his battlefield successes with decisive action. But Bragg was of humbler origins. Born into the lower class of Warren County, North Carolina, Bragg saw a military career as the way to move into the social circles that excluded him due to the circumstances of his birth. He distinguished himself while serving in the Mexican War, and he and Jefferson Davis came to admire each other's abilities on the battlefield. Despite this, however, Bragg proved lacking in the skills necessary for high command. His men also lacked respect for him and, indeed, were almost on the verge of mutiny as the Battle of Chickamauga opened. Still, Davis remained stubbornly loyal to

The Civil War and Its Aftermath

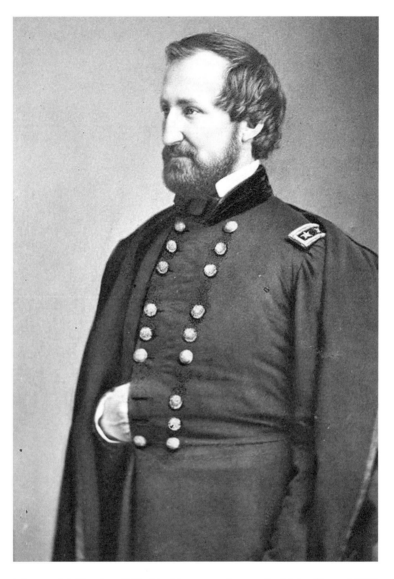

Though he was intelligent, well liked by his men and energetic, Major General William S. Rosecrans's failure to confirm a report that a gap had opened up in his lines at Chickamauga proved disastrous for the Army of the Cumberland. *Courtesy of the Library of Congress, LC-DIG-cwpb-06052.*

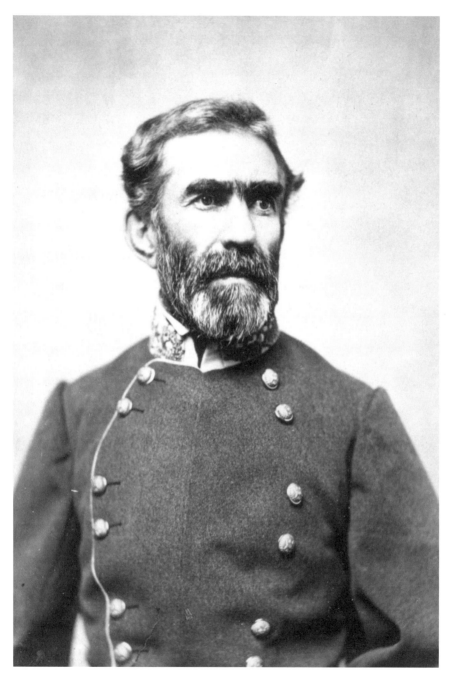

Though hardly incompetent, General Braxton Bragg nevertheless lacked the skills necessary for high command, and his victory at Chickamauga ultimately proved hollow. *Courtesy of the Library of Congress, LC-USZC4-7984.*

Bragg, whom he had promoted to one of only seven full generals to serve in the Confederacy. Before Chickamauga, Bragg served as a corps commander at Shiloh and overall commander at Perryville and Stones River.

The objective during the Battle of Chickamauga was the city of Chattanooga. Its location on the Tennessee River, the good roads that passed through it and its importance as a rail center all converged to make it a key Union objective. If the Federal troops were successful, the city would become a critical staging point into the Deep South and the heart of the Confederacy—the key to eventual overall victory over the South. Rosecrans occupied Chattanooga on September 9 after Bragg withdrew his forces into Georgia, eventually reaching Lafayette. On September 18, Bragg ordered his forces back toward Chattanooga with the intention of placing his army between Union forces and the city. He soon occupied the west bank of Chickamauga Creek. Much of the area was heavily forested, making combat even more difficult for the soldiers of both sides. Communications and reconnaissance also proved difficult, as both couriers and cavalry found much of the area tough to navigate.

The next morning, fighting started just after dawn as Confederate cavalry under the command of General Nathan Bedford Forrest engaged General George Thomas's Fourteenth Corps, infantry troops, under General John M. Brannan. Surprised, Brannan expected to find a single brigade of enemy soldiers, and his trouble only intensified as Forrest's men received reinforcements by a division of infantry. The fighting soon spread and drew more and more men into the battle. Just before noon, Confederate General St. John R. Liddell's division smashed into the right flank of Brigadier General Absalom Baird's division, which broke and fled. The lines of action then moved southward as both Bragg and Rosecrans sent troops into the fray as soon as the men arrived on the field.

In the afternoon, the fighting moved back and forth, but the numerical superiority of the Confederates eventually, albeit slowly, succeeded in pushing the Federals farther back. As the fierce fighting continued, a gap appeared in Rosecrans's line. General Stewart ordered his division forward, breaking the right flank of General H. Van Cleve's line and forcing it across the Lafayette Road.

But Union General William B. Hazen's brigade and artillery fire eventually checked the Confederate advance. The Union line, while forced back to Lafayette Road, did not break. Union forces also held despite the best efforts of General Evander Law and Hood's division, of which Law was in temporary command. General Phil Sheridan's arrival, with support from Wilder's "Lightning Brigade," had reinforced the Union line.

A Brief History of Catoosa County

Wilder's brigade had a distinct advantage over its Confederate counterparts. By arming his men with the then new Spencer repeating rifle and providing (or rather appropriating) horses for them, Wilder took an average brigade and turned it into perhaps the fastest and best-armed infantry in the Union army. Each of Wilder's men, able to fire twenty shots per minute, had nearly seven times the firepower of the average soldier armed with the usual muzzleloading musket.

The fighting lasted all day, and the Confederates failed to dislodge Union forces from their positions. The Federals held Lafayette Road, the protection of which had become Rosecrans's principal objective that afternoon. By sunset, Rosecrans had engaged his entire army, while Bragg still held three divisions in reserve. But even as night fell, the fighting continued—a rare occurrence during the Civil War, as the technology and tactics of the time made fighting after dark not only difficult, but even more dangerous than daylight combat. Still, the Confederates advanced on the Federal troops, which had reoccupied Winfrey Field earlier that afternoon. Both sides lost nearly as many soldiers from their own fire as from enemy fire. It was not only a tragic close to the day's fighting, but a pointless one as well—the Federals had already decided to pull back from the field by the time the Confederates attacked.

Weary and wet from the sweat of battle and a warm fall sun, the soldiers received little rest that night. The temperature plummeted after sunset,

Reinforcements arrive at Catoosa Station from the Army of Northern Virginia. *Courtesy of the Catoosa County Historical Society.*

and those attempting to rest listened in sorrow to the groans and pleas from the wounded men all around them. Many found sleep elusive as they contemplated the next day and their own fate. In all, approximately seventy-five hundred Confederates and seven thousand Federals were either killed, wounded or missing on the first day of Chickamauga.

Bragg's numbers, however, received a boost later that night as two divisions under the command of Major General James Longstreet finally arrived. General Lee agreed to allow Longstreet to leave Virginia, as Confederate President Jefferson Davis sought to reinforce Bragg after the twin Confederate disasters earlier that year at Gettysburg and Vicksburg. Longstreet arrived at Catoosa Station (a wooden platform with a station house approximately four miles south of Ringgold) at 2:00 p.m. after a nine-day train ride. He lacked someone to serve as a guide—Bragg had sent no one to meet him—and so did not arrive at Chickamauga until shortly before midnight after the first day of battle had already ended.

The Second Day and Its Aftermath

Union Lieutenant John Young of the Nineteenth Illinois Infantry later recalled the eerie scene early in the morning on September 20 before hostilities resumed:

> *The Rebels moved a large force immediately in our front. The intervening ridge and timber on the other side prevented our seeing them. The battle of Sunday had not yet opened, and an oppressive stillness was over everything. We were suddenly startled by ringing words of command being given to the Rebel force opposite; every order came clear and distinct over the ridge, we could hear the rattle of their accoutrements as they moved into position. We expected them every moment to appear over the elevation. It seemed a hopeless task to attempt resistance to such a force as we knew were near.*

Rosecrans had concentrated his forces during the night, while Bragg laid plans to attack the Union left flank and to again attempt to position his army between Chattanooga and Federal forces. He possessed the initiative, but a delay by General Polk (who was supposed to attack at dawn, but whose orders from Bragg did not arrive in time) held up the advance for several critical hours. The attack did not begin until about 9:30 a.m. Longstreet received orders to follow up on Polk's attack and, from north to south, pummel the Union army. It almost worked.

But the delay, combined with the disjointed nature of the attack, gave the Union troops an opportunity. Shifting their reserves to blunt the onslaught, the Federals successfully, but barely, held back the Confederate forces. As the fighting wore on, both sides found themselves in a protracted long-range shooting match.

Poor communication and perhaps a bruised ego were about to present the Confederates with the key to the field. Rosecrans became convinced (incorrectly) that a gap had opened in his lines, and he ordered the imaginary hole closed. With that single command, he created a real gap. The disaster that followed cannot entirely rest on Rosecrans's shoulders, however; depending on which version of the story one hears and by whom it is related, one can come to other conclusions. The order Rosecrans issued was directed to General Thomas J. Wood and read:

> *Headquarters Department of Cumberland,*
> *September 20th–10:45 A.M.*
>
> *Brigadier-General Wood, Commanding Division:*
>
> *The general commanding directs that you close up on Reynolds as fast as possible, and support him.*
>
> *Respectfully, etc.*
> *Frank S. Bond, Major and Aide-de-Camp*

Some versions of what happened claim that Woods, reprimanded in front of his own men by Rosecrans, was out for revenge. He purportedly kept the order, placing it in his own pocket, to ensure that a defense existed for an action he knew to be irresponsible and even unmistakably dangerous. Other versions insist that no such reprimand occurred and that Woods, assuming the commanding general had a better understanding of the battle overall than he did, followed the orders.

Whatever the actual circumstances surrounding the two men, Rosecrans issued the order and Woods followed it. Within half an hour of the gap opening in the Union lines, Longstreet's troops fought their way through the hole. Routed, half of the Army of the Cumberland retreated, and even Rosecrans found himself driven in humiliating defeat from his own battlefield headquarters.

What had at first appeared to be a promising day for the Union army turned into a defeat. But as Federal forces began a disorganized retreat back

The Civil War and Its Aftermath

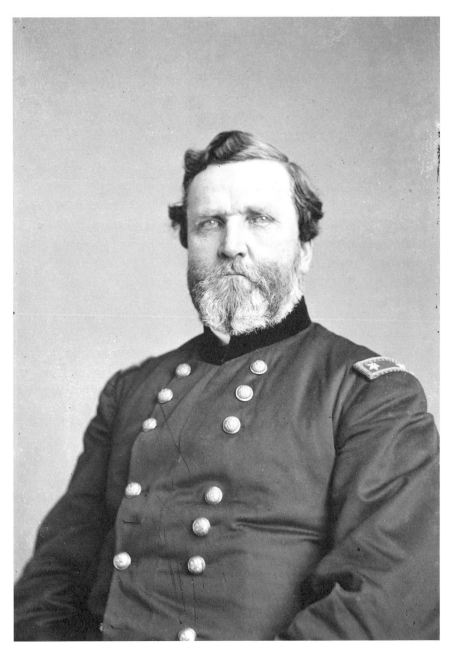

The "Rock of Chickamauga," George H. Thomas was one of the best generals in the Union army and likely saved the Army of the Cumberland from destruction after its rout at Chickamauga. *Courtesy of the Library of Congress, LC-DIG-cwpbh-01069.*

toward Chattanooga, the situation threatened to go from bad to worse, from a resounding defeat to an outright disaster. General George H. Thomas took command of the remaining Union troops, consolidating his forces, and formed a battle line at Snodgrass Hill.

George Henry Thomas was born in Southampton County, Virginia, and came to be known as the "Rock of Chickamauga" for his stand on Snodgrass Hill. He graduated twelfth in his class from West Point, served in the Mexican War, fought the Seminoles in 1841 and later served as an instructor at West Point. When the Civil War broke out, Thomas, unlike many of his fellow Virginians—most famously including Robert E. Lee—remained with the U.S. Army. He served with distinction throughout the war, and while there was some initial distrust because he was from Virginia, Thomas eventually proved his loyalty. Though his legacy has failed to catch the popular attention (Thomas did not write a memoir, shunned politics and destroyed his personal papers), he is perhaps only third in line behind Ulysses S. Grant and William T. Sherman as the best general the Union produced during the war.

Snodgrass Hill, named for George Washington Snodgrass (a farmer who had moved to the area from Virginia in 1848), became the most important site on the Chickamauga Battlefield. It formed the easternmost point of a series of hills and ridges that, after the battle, came to be known as Horseshoe Ridge. Much of the area was thickly forested and contained dense underbrush. Visibility was limited to, at best, about three hundred feet and, at worst, just a few yards.

Shortly after noon, segments of the routed forces teamed up with men held in reserve to make their stand at Snodgrass Hill. The smoldering earth made the combat even worse—as fire spread across the hill, men who lay wounded slowly burned alive. As he approached the battle, Lieutenant Colonel David Magee, commanding the Eighty-sixth Illinois Infantry, witnessed the scene and later recorded it in his report:

> *A more desolate sight never met the eye. The entire country seemed to be one smoking, burning sea of ruin. Through this blazing field we marched, while the rebel battery played upon us with spherical case, shell, and almost every conceivable missile of death.*

Thomas, who heard the din of battle from the area of Snodgrass Hill, rode over and soon realized the importance of the hill. He could use it to stave off further disaster and allow the army to escape back into Tennessee. He set up his headquarters on the opposite side of the hill and then coolly rode along the

line offering encouragement to the soldiers and acting as a steadying presence. They faced repeated and determined assaults from the Confederates, but owing to their favorable location on the high ground they were able to lie on the ground and fire down the hill, a far better position than the Confederates held. The Union forces successfully repulsed every advance the Southerners made, though the Rebels did come close to turning the right end of the Union line. The timely arrival of a Union reserve corps under General Gordon Granger, however, held the line and checked their advance. Once darkness fell, Thomas ordered his men from the field back to Chattanooga.

Chickamauga was the worst Union defeat since the First Battle of Bull Run, but Thomas's action likely saved the Army of the Cumberland from complete destruction.

Trapped in Chattanooga

Though the Battle of Chickamauga was over, the Union army was only literally out of the woods; figuratively speaking, they were still there. The Confederates trapped the Federal forces in Chattanooga as the Southerners took commanding positions on the heights of Lookout Mountain and Missionary Ridge. The Southerners strategically placed their artillery and succeeded in blocking Union supply lines by river, road and rail. Rosecrans had but three options: rescue, capitulation or starvation.

Fortunately for Rosecrans, reinforcements had been ordered to Chattanooga. In late October, General "Fighting Joe" Hooker arrived with twenty thousand men. Rosecrans, considering options but still doing nothing, soon found himself replaced by Thomas at the order of General Ulysses S. Grant after he assumed command of all Union forces in the Western Theatre. Soon afterward, Grant arrived in Chattanooga, and Federal fortunes quickly turned around. Four days after his arrival, on October 27–28, Union forces seized Brown's Ferry on the Tennessee River and opened a vital supply line to the near starving soldiers (currently living on reduced rations). In mid-November, sixteen thousand more troops arrived under the command of William T. Sherman. With Sherman there, Grant soon set his plan in motion and events moved quickly. On November 23, Union troops captured Orchard Knob. By the morning of the twenty-fifth, they had taken Lookout Mountain. And by that evening, Confederate troops fled in disorder after three separate forces, one each commanded by Sherman, Hooker and Thomas, attacked and drove them from Missionary Ridge. What was left of Bragg's army retreated later that night.

CHAPTER 7

THE BATTLE OF RINGGOLD GAP

...hold this position at all hazards...

—*Commanding General Bragg to General Patrick Cleburne at Ringgold, November 25, 1863*

During the rout at Missionary Ridge, the Confederates lost the city of Chattanooga, and Bragg and the Army of Tennessee were forced into retreat. They moved southward into Georgia, but Bragg had a problem—his artillery and supply train, bogged down in mud, moved far too slowly for an army in so dangerous a situation. Federal forces were right behind him.

On the night of November 25, 1863, Bragg sent General Patrick Cleburne to the mountain pass at Ringgold Gap, ordering him to hold the position until the army and his artillery were safely through. The order reached Cleburne, encamped on the west bank of the East Chickamauga Creek, at about midnight. Cleburne went ahead to scout the position he was to take at the gap and then returned to camp. At 3:00 a.m., he roused his men from sleep. When they reached the gap, Cleburne positioned his force of forty-one hundred men in the cold, predawn darkness and waited for the Union advance.

Cleburne, born on St. Patrick's Day (March 17) 1828, was originally from Ovens, County Cork, Ireland. After failing his entrance exam to Trinity College of Medicine, he joined the British army and served in the Forty-first Regiment of Foot. His unit maintained order during the Great Famine (better known as the Irish Potato Famine). From 1845 through 1850, approximately one million people died and another million left Ireland to escape the tragedy. In 1849, following in their footsteps, Cleburne moved to America. He briefly

A Brief History of Catoosa County

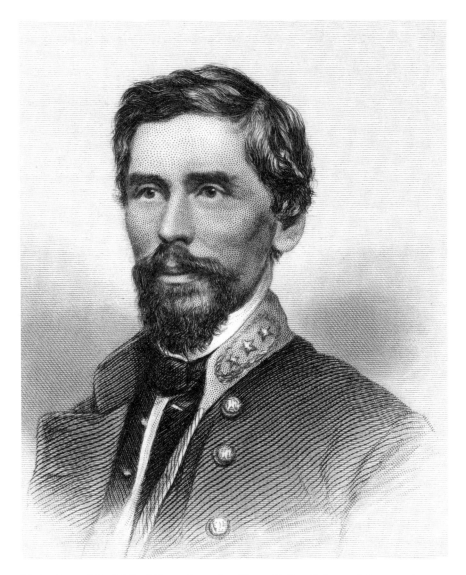

Major General Patrick R. Cleburne's stand at Ringgold Gap likely saved the retreating Confederate army from destruction. *Courtesy of the Library of Congress, LC-USZ62-107446.*

The Civil War and Its Aftermath

lived in Ohio before settling in Helena, Arkansas. He became a pharmacist and was soon welcomed into Helena's society. In 1856, he joined a law firm, and in just five years he had risen to become a senior partner. When the war broke out, he left the firm behind and joined Confederate forces as a private. In doing so, he renounced his recently attained status as a naturalized citizen of the United States.

Cleburne's rise as a soldier was even swifter than his rise as an attorney. Elected captain of the Yell Rifles, the local militia company, in less than a year Cleburne received command of the entire contingent of Confederate forces in Arkansas. On March 4, 1862, he received a promotion to brigadier general, and just nine months later, on December 13, he became one of only two foreign-born officers to attain the rank of major general in the Confederate army (the other being the Frenchman Prince de Polignac).

Cleburne served with distinction and fought at Shiloh, Richmond (Kentucky), Perryville, Stones River, Chickamauga and most recently, before Ringgold Gap, at Chattanooga, where, during the Battle of Missionary Ridge, he faced a much larger force commanded by General Sherman and successfully held his line. Only when the rest of the Confederate troops panicked and ran did Cleburne, seeing that he and his men would be cut off otherwise, give the order to retreat. Now, Cleburne again found himself called upon to accomplish nearly the same task at Ringgold: hold the high ground against a much larger force. If he failed to protect the pass, Bragg's army faced likely destruction.

Approaching the Confederate troops at Ringgold Gap was Joseph Hooker. He commanded twelve thousand men—three times the force under Cleburne—and did not expect resistance. He incorrectly believed that Confederate forces were in full retreat, and upon reaching the gap, the Confederates took him completely by surprise.

Nicknamed "Fighting Joe" by his men, Hooker was born in Hadley, Massachusetts. He graduated from West Point in 1837 (twenty-ninth in his class of fifty) and served during the Mexican War. Appointed brigadier general of volunteers at the beginning of the war, Hooker was third (behind George B. McClellan and Ambrose Burnside) in the line of generals whom Lincoln placed in command of the Army of the Potomac. Hooker improved morale and better organized the army, but he failed to assert his characteristic aggressiveness on the battlefield. He resigned as commander of the Army of the Potomac shortly after the Union disaster at Chancellorsville. Lincoln then placed George Gordon Meade in command of the army, just before the Battle of Gettysburg.

A Brief History of Catoosa County

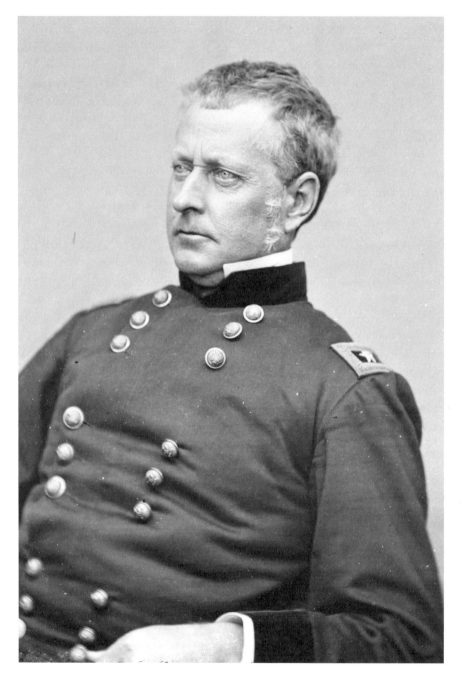

Major General Joseph Hooker, despite commanding three times the number of men that Cleburne did, was unable to dislodge the Confederates from Ringgold Gap. *Courtesy of the Library of Congress, LC-DIG-cwpb-06979.*

The Civil War and Its Aftermath

Hooker, however, began to rebuild his reputation and played an important role in Grant's victory at Chattanooga. Now, at Ringgold, he had another opportunity. At about seven o'clock that morning, Confederate soldiers, ordered by Cleburne to hold their fire until the last possible moment, opened fire on Hooker's men, forcing them to stagger back. Throughout the battle, Cleburne's strong position offset Hooker's superior numbers. Hooker tested first the right and left flanks of his enemy, but he was unable to move the Southerners. For five hours they clashed, Hooker gaining little ground and, under withering fire, losing far more men than Cleburne. The Seventh Ohio, hit especially hard, lost its colonel, William Creighton. At about noon, Cleburne finally ordered his men to retreat. He had lost 221 men (Hooker lost 507), but the wagons, artillery and men of the Army of Tennessee were safely through the gap.

In Ringgold, Hooker did nothing further toward rebuilding his reputation. Grant, however, did not seem overly disappointed, though he admittedly considered the engagement "unfortunate." He nevertheless recorded (inaccurately) that Hooker had captured "3 pieces of artillery and 230 prisoners, and 130 rebel dead were left upon the field."

On January 9, 1864, *Harper's Weekly* ran the following report:

> *THE BATTLE OF RINGGOLD.*
>
> *THE charge of Colonel Creighton's brigade at the battle of Ringgold, a gallant though disastrous assault, which ended the series of battles lately fought by the different commands of General Grant, is presented to our readers on page 21.*
>
> *Colonel Creighton, killed at the very front of his men, with his last breath gave them, "Three cheers for the First Brigade, and God save the Union!" Nearly every officer of his regiment, the Seventh Ohio, was either killed or wounded, and the loss in the brigade was great.*
>
> *The warm feeling between the divisions of Generals Geary and Osterhaus, engendered by their mutual gallantry in their side-by-side struggle for our cause, was a gladdening sight to witness.*

Despite the introduction's sensational tone, the Seventh Ohio Infantry did indeed endure harsh losses at Ringgold. The story, however, ignored the larger ramifications of the battle regarding the escape of Bragg and his army. Such omissions, as well as exaggerations and outright fabrications, were common in newspaper reports of the time, and this example is mild. The *New York Times* ran a story after the Battle of Chickamauga that claimed

that the severed heads of Union soldiers were found mounted atop stumps and rifles. This, of course, is complete fiction.

Grant arrived in time to observe the fighting. He was uncertain as to the path Bragg might take, thinking it possible that the commander of the Army of Tennessee might head toward Cleveland and then on to Knoxville in an attempt to unite with Longstreet. But he observed otherwise. He later wrote in his memoirs, paying a perhaps unintentional compliment to Cleburne:

> *When I arrived at Ringgold, however, on the 27th, I saw that the retreat was most earnest. The enemy had been throwing away guns, caissons and small-arms, abandoning provisions, and, altogether, seemed to be moving like a disorganized mob, with the exception of Cleburne's division, which was acting as rear-guard to cover the retreat.*

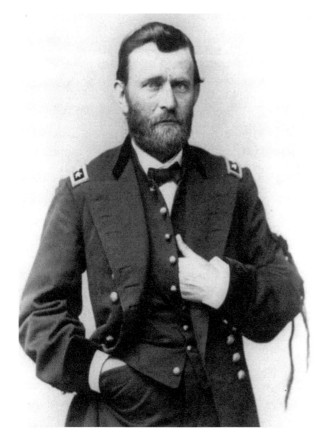

During the battle of Ringgold Gap, Ulysses S. Grant was the supreme commander of the Union armies of the Western Theatre of the war. Lincoln shortly thereafter chose him to become the third military commander in U.S. history to assume the rank of lieutenant general, first held by George Washington and later by Winfield Scott. *Courtesy of the Library of Congress, LC-USZ62-1770.*

The Civil War and Its Aftermath

After his withdrawal from Ringgold, Cleburne and his men reached Tunnel Hill, where he began to set to paper an idea that had been formulating in his mind: the training and arming of slaves to fight for the Confederacy in return for their freedom. Eventually reaching the ear of the president of the Confederacy, Davis suppressed the idea, only relenting when Robert E. Lee later called for the same plan (though virtually no slaves saw combat in service to the Confederacy). Cleburne went on to serve with further distinction until he was cut down at the bloody Battle of Franklin, Tennessee, on November 30, 1864. Confederate General William Hardee later summed up Cleburne's service: "Where his division defended, no odds broke its lines; where it attacked, no numbers resisted its onslaught, save only once—and there is the grave of Cleburne and his heroic division."

Evaluating the events from a modern perspective, nearly a century and a half after the battle, one might attempt to designate Cleburne the "Hero of Ringgold Gap." This would perhaps lessen acknowledgement of his other achievements. Still, it is not an undeserved appellation. He was one of the best divisional leaders on either side of the conflict, but at Ringgold he not only successfully fought off superior enemy forces, but he also saved the entire Army of Tennessee. On February 4, 1864, he and his men received official thanks in a special resolution from the Confederate Congress:

> *Thanks of Congress to Major General Patrick R. Cleburne and his command. Joint resolutions of thanks to major General Patrick R. Cleburne and the men and officers under his command, for distinguished services at Ringgold Gap, in the State of Georgia, November twenty-seventh, eighteen hundred and sixty three.*

OCCUPATION

With the withdrawal of Cleburne, Federal forces had control of Ringgold. Immediately after the battle, Hooker received orders from Grant to appropriate flour and wheat from any nearby mills and then to destroy the mills, along with any other property that the Confederates could possibly use. By this time, Sherman and his troops had reached Graysville, and Sherman met Grant in Ringgold.

Grant used the house of William L. Whitman as his headquarters that day. Whitman, a prominent merchant in Ringgold, was born in 1826 and came to the town sometime in 1847. After the founding of Catoosa, he

served as the first county treasurer and also as one of the ruling elders of Old Stone Presbyterian Church. He married Cordelia A. Young and then, sometime after she died in 1857, married her younger sister, Margaret. His home, built in 1863, still stands today at the intersection of Tennessee and High Streets.

As he was leaving, Grant supposedly offered Margaret Whitman fifty dollars for his use of her home. She refused the money and instead asked for Confederate currency—a defiant, determined attitude considering the state of the Southern economy in late 1863. At that point, a Confederate dollar was worth less than eight cents in gold. Grant purportedly quipped, "She certainly isn't whipped yet," and his men are said to have cheered her when they left. Grant then accompanied Sherman back to Graysville. He remained there overnight and then returned to Chattanooga the next evening. He directed Sherman to march toward Knoxville to relieve Major General Ambrose Burnside, who was facing off against Lieutenant General James Longstreet. But Sherman would soon come back to Georgia.

The *New York Times* reported that, on December 1, "Gens. Hooker and Palmer evacuated Ringgold this morning, after burning the mills, depots, public buildings and railway bridges." For the troops that remained, winter

William L. Whitman was prominent in local affairs, and his home served as Grant's headquarters during his brief stay in Ringgold. *Photo by Jeff O'Bryant.*

The Civil War and Its Aftermath

was fast settling in, and the men on both sides prepared to wait it out until spring. Federal troops occupied Catoosa Springs and Ringgold; most, however, returned to Chattanooga. Those who did not leave effectively pillaged the area, consuming food stores and driving away local residents. Ringgold was, with the exception of soldiers, virtually deserted. By the time the troops moved on in 1864, much of Ringgold lay in ruins.

The occupation aside, the three principal Civil War episodes that occurred in Catoosa County were Southern victories: the Andrews Raiders were captured; Bragg drove Rosecrans out of northwest Georgia and back into Chattanooga; and Cleburne successfully defended the gap until Confederate supplies and troops had safely passed through.

But as Cleburne fell back from Ringgold, the Confederacy was already dying. Just the week before the battle, Lincoln had delivered his Gettysburg Address, and the "new birth of freedom" of which he spoke was already nearing the completion of its labor. The three-day battle at Gettysburg, combined with the surrender of Vicksburg the following day (July 4), ended all hope of not only a successful invasion of the North, but also European intervention on the side of the South. The Northern peace movement, slowed by Union victories and coupled with Sherman's capture of Atlanta, failed to see its presidential candidate replace the Great Emancipator. Lincoln easily won reelection, and so the government of the United States remained dedicated to preserving the Union. The coming year would pit Grant against Robert E. Lee, the former tenaciously pursuing the latter until Lee's Army of Northern Virginia was battered, starved and decimated. On the morning of April 9, 1865, Lee acknowledged the situation of his men and his country, surrendering to Grant at Appomattox Court House, Virginia. A few more skirmishes followed, but the war was over.

CHAPTER 8

RECONSTRUCTION

With malice toward none, with charity for all, with firmness in the right as God gives us to see the right, let us strive on to finish the work we are in, to bind up the nation's wounds, to care for him who shall have borne the battle and for his widow and his orphan, to do all which may achieve and cherish a just and lasting peace among ourselves and with all nations.

—Abraham Lincoln, Second Inaugural Address

The South lay in ruins after the war. With a wrecked economy and many of its principal cities, such as Richmond, Atlanta and Charleston, devastated, and numerous smaller towns like Ringgold shattered as well, the pieces ultimately took decades to pick up. Much of the flower of Southern youth—boys and young men who had so confidently set off to what they believed would be a short conflict—were either dead or maimed. Now that the Confederacy itself lay dead, the Federal government had the task of turning a nation geared for war toward one capable of rebuilding. It also questioned the status of Southerners. Were they vanquished foes or returning brothers, and, in either case, how would they be readmitted to the Union? Central to the debate was the question of the newly freed slaves. They had been the power behind the Southern economy before and during the war. Now, with their newly attained freedom, they had to determine their futures for themselves. But many Southerners, resentful at their defeat and bitter toward the former slaves, were determined to keep that future anything but bright.

Lincoln's words in his Second Inaugural Address were not just for binding up the wounds of the Union soldiers and caring for their widows and

orphans. As it became increasingly clear that the Union would triumph, Lincoln considered how best to treat the returning states. His final judgment was to welcome them back with open arms and to be as lenient as possible. Others, however, were not so friendly toward the South. The Wade-Davis Bill, a proposal in Congress that called for a full 50 percent of a state's white male population to swear allegiance to the Federal government before it could form a state government, enjoyed wide support among the Radical Republicans. Lincoln favored allowing just 10 percent to take such an oath.

Though they disagreed on the particulars, both sides were committed to remaking the South by establishing free labor. In January 1865, even before the war ended, Congress passed the Thirteenth Amendment, abolishing slavery in the United States. The institution responsible for so much human misery—from the horrific conditions of the slave ships that initially brought Africans to the New World to the degraded conditions of plantation life—finally and forever died. Congress quickly followed by creating the Bureau of Refugees, Freedmen and Abandoned Lands (popularly known as the Freedmen's Bureau). General William T. Sherman's issue of Special Field Order No. 15 had, in January of that year, set aside the abandoned lands of the Sea Islands of Georgia and South Carolina for freed slaves.

The Freedmen's Bureau, designed to help any refugees regardless of the color of their skin, nevertheless held as its primary mission the aid of newly freed slaves. It provided food, clothing, medicine and fuel. It also established schools and attempted to protect the freedmen not only from mistreatment by employers, but also from general intimidation and abuse.

The assassination of President Lincoln complicated the issue. Andrew Johnson, who became president after Lincoln's death, had no inclination or intention to remake the South and sought to quickly reintegrate the wayward states back into the Union. He offered amnesty to all who would take an oath of allegiance, reversed Sherman's Special Field Order No. 15 and appointed provisional governors for each state who were to organize state constitutional conventions. So long as they outlawed slavery and renounced secession, Johnson asked nothing more of them. Southern states quickly formed governments, passed black codes (designed to restrict the rights of freedmen) and returned former Confederates to political power.

Congress was outraged, and while Johnson considered Reconstruction complete, it took the matter out of the president's hands. It passed the Fourteenth and Fifteenth Amendments, granting, respectively, citizenship to anyone born or naturalized in the United States and the right to vote regardless of race or previous condition of servitude. Congress also refused

to admit former Confederates to the chamber and became increasingly hostile to Johnson. The antagonism between the two sides eventually led to the impeachment of Johnson, who escaped removal from office by just a single vote in the Senate.

Under Johnson's plan, Georgia created a new constitution that did not give freedmen the right to vote and also did not allow them to testify against whites in court. When Congress retaliated against Johnson, Georgia and the other Southern states, with the exception of Tennessee, found themselves under military rule. With freedmen votes, Republicans quickly rose to political power in Georgia, and in 1870, the state became the last to be readmitted to the Union.

Many Southern Democrats were determined to hold onto as much of their former way of life as possible. The Ku Klux Klan was organized as a terrorist group that intimidated, assaulted and killed to achieve its goal of white domination, establishing a pattern that would continue even as the group's power repeatedly waxed and waned over the coming years. In 1868, over three hundred lynchings occurred, and according to Tuskegee Institute figures, Georgia placed second only to Mississippi in leading the nation in this form of terrorism. From 1882 until 1968, there were 531 lynchings in Georgia—492 African Americans and 39 whites.

Main Street, Ringgold, as it appeared in 1906. *Courtesy of the Catoosa County Historical Society.*

Most Georgians made their living from the land, including not only the newly freed slaves, but their white neighbors and the former slaveholding class as well. Eventually, Georgia's cotton textile industry grew, and the state began producing goods that catered to its mostly agrarian residents—notably cattle feed and fertilizer. Georgia also began to develop and exploit its natural resources. Atlanta, rebuilding and recovering from the devastation left behind by Sherman, became the state capital in 1868 and eventually became an important and prosperous manufacturing and commercial center. Today, it is one of the the largest cities in the old Confederacy.

In 1877, Republicans and their candidate, Rutherford B. Hayes, made a political deal to take the presidency after a disputed election. As part of the agreement, they abandoned their policies to remake the South. Democrats quickly assumed power and cut funding to schools (especially African American schools), implemented literacy tests and poll taxes and closed political primaries to African Americans. Perhaps most humiliating of all were the segregation laws that mandated separate facilities, such as drinking fountains, restrooms and seating areas. The standard of "separate but equal" actually only meant separate. Reconstruction had failed, and the consequences of that failure would reverberate throughout the next one hundred years and beyond.

Catoosa County Rebuilds

Records are unclear, but it is likely that Catoosa County sent nearly seven hundred of its men (in six divisions) to fight for the Confederacy. They saw action as far away as the Battles of Gettysburg, Vicksburg, Richmond and Fredericksburg. Some fought closer to home at Chattanooga, Shiloh, Atlanta and even Chickamauga and Ringgold. A few witnessed the scene at Appomattox Court House. Those who survived these battles and returned home found life very different from when they had left.

Catoosa's population had decreased by 13 percent, from 5,082 in 1860 to 4,409 in 1870 (of which 616 were African American, all of whom were now free). The landscape was devastated, despite the fact that, contrary to popular local myth, Sherman's March to the Sea did not begin until he left Atlanta for Savannah on November 15, 1864. But the fall of Chattanooga had opened the way to Atlanta, and after Cleburne withdrew from Ringgold Gap, Catoosa remained under Federal control for the remainder of the war. While not completely destroyed, it was nevertheless ravaged. As the national

The Civil War and Its Aftermath

and state governments fought each other over Reconstruction, Catoosa and other Southern communities struggled to rebuild. Education, prosperity and trade had all suffered during the war, and they now struggled to redevelop and grow under Reconstruction and beyond.

Education in Catoosa eventually developed from an independent system of numerous schools and academies. There were nearly fifty, spread throughout the county and throughout various periods of operation from the founding of the county through the mid-1900s. Typical of other Southern schools at the time, many were one-room buildings (some made from log) or churches that also served as schoolhouses. Students of various ages gathered together and generally sat under the instruction of a single teacher. Home instruction was also common, but regardless of the venue one could, for the most part, expect only the rudiments of reading, writing and arithmetic. Just before the Civil War, the state government had attempted to establish a uniform school system, but the war precluded virtually all other major government concerns. Even after the war ended and state law mandated free public education, the funds simply were not available to make the law a reality. Nearly a century passed before Georgia established the familiar nine-month school year.

In an environment already short of funds, segregated schools and African American students found themselves with inadequate and outdated textbooks and facilities. An educator teaching African American students could also expect less pay than his or her counterparts who taught white students. These separate but unequal practices officially ended in 1954 with the Supreme Court decision in *Brown v. Board of Education*. However, in many areas they continued de facto until the early 1970s. Ringgold High School did not integrate until 1966.

The first school superintendent of Catoosa, Marcus Lansford, was the descendant of an indentured servant from Bristol, England, and was born on February 18, 1836, in Walker County. He studied medicine at the University of Tennessee at Knoxville until he joined Confederate forces as a private in the Fifth Tennessee Cavalry at the outbreak of the Civil War. Captured after his horse was shot out from under him (it fell on him and broke his leg), he was sent to the prisoner of war camp at Johnson's Island, Ohio, where he remained a captive until after the war ended. He returned, taught school and, in 1869, purchased a 250-acre farm in Catoosa. Even as a farmer, he continued to teach and, from 1880 to 1882, served as superintendent of schools. He died on July 15, 1924.

With a bleak economic outlook, many residents moved west; others barely eked out a living subsisting on what they could produce by farming. Slowly,

however, conditions improved, and, if not actual prosperity, at least progress came. Trade slowly resumed, and the depot, damaged by Hooker's guns during the Battle of Ringgold Gap, underwent repairs, as did the rail line itself. Visitors began returning to Catoosa Springs, and stores reopened along the dirt road that ran through Ringgold.

Living off the land remained the dominant means of survival. Farms, of which there were 325 within the county in 1870, were the driving force behind the local economy. In that year, they produced a total of 43,366 bushels of wheat, 90,855 of Indian corn, 19,909 of oats and 40,879 pounds of butter. The county produced only 96 bales of cotton that year. Livestock totals for that year included 542 horses, 834 milch cows, 1,225 head of other cattle, 2,447 sheep and 4,399 swine. By the turn of the century, there were signs of industry slowly appearing in and around Ringgold.

The construction of the Dixie Highway also helped the local economy. As the automobile made travel more common, businesses sprang up to support that travel, and Ringgold was no exception. As the first town in Georgia along the Dixie Highway route, Ringgold soon offered gas and meals to tourists. But car service and restaurants were only the most obvious industry.

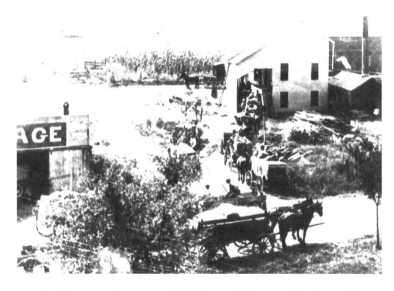

Wagons make their way to the cotton mill in Ringgold. *Courtesy of the Catoosa County Historical Society.*

The Civil War and Its Aftermath

A whole culture of tourist destinations developed, and none were more prominent than Civil War sites. Though Ringgold failed to take advantage of this, it naturally lay, if not as a principal stop on a traveler's itinerary, at least along the route visitors would take into Georgia either on their way to the beaches of Florida or, perhaps, as they followed Sherman and Joseph E. Johnston (who shortly replaced Bragg after the Battle of Ringgold Gap) on their warpath toward Atlanta and Sherman's subsequent March to the Sea. The route was officially completed in the fall of 1929, and on November 4, during the dedication of the completion of the final segment of the road from Chattanooga to Atlanta, a motorcade of two hundred cars passed through Ringgold.

But the Roaring Twenties didn't roar in Catoosa County, and by the end of the decade, that roaring became a collective whimper across the nation. In late October 1929, stock values began to plummet, and on the worst day of the panic, October 29, the value of U.S. stocks dropped $10 to $15 billion. The crash, however, merely announced the Great Depression. The causes leading to it were rooted in the lingering effects of World War I (especially in the European countries) and the fact that spending outpaced earnings for

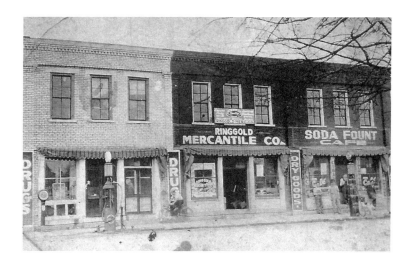

The completion of the Dixie Highway helped bring tourist money to Ringgold, the first stop in Georgia for travelers seeking gas or food. These buildings still line Ringgold's Main Street. *Courtesy of the Catoosa County Historical Society.*

many Americans. Farmers, too, struggled to get by as the profits realized on their produce were low.

The Depression began in America, but soon spread to the other industrialized nations of the world. At its worst point, in 1933, more than fifteen million Americans—a full 25 percent of the nation's workforce—were unemployed. In Catoosa County, as in much of the South, the Depression only served to deepen the already poor economic conditions. Georgia was already suffering an economic downturn, the boll weevil having laid waste to the cotton production across the state, and so the effects of the Depression were slow to hit Catoosa. Most of the county's citizens continued as they had before and lived by farming and trading what they produced or grew for what they could not make themselves. The crash in New York City simply did not register, at least not immediately. Even after World War II, when much of the rest of the nation experienced rapid growth, the South, Georgia and Catoosa persisted in economic anemia until relatively recently.

African Americans, despite initial and promising gains, soon found themselves overlooked by a North now focused on the future prosperity of the nation. Many Southerners, struggling to rebuild, still found energy to remain openly hostile to the freedmen, and they passed their racism down to their children. Another one hundred years would pass before African Americans would begin to lay full claim to the promise of liberty purchased by the lives lost by so many.

Despite these problems, other scars from the war were slowly beginning to fade. After the Reconstruction period ended, Northerners and Southerners—at least, many of those who had fought each other on the battlefields—began to mend the rift in their relations resulting from the war. The friction caused by carpetbaggers (Northerners who moved to the South during Reconstruction) and scalawags (white Southerners who supported Reconstruction) had lessened, and those who fought through the war and survived began to hold reunions with their former comrades in arms. Eventually, these gatherings grew to encompass their former enemies, as well.

The war was now but a memory to them, but it was still not quite over. It had accomplished its official goal—preservation of the Union—and it had accomplished its larger goal, which was the end of slavery. Now it was time to complete the reconciliation, and the first permanent monuments to that spirit of renewed friendship appeared on the soil of Catoosa County.

CHAPTER 9

THE FIRST NATIONAL MILITARY PARK

From this time until dark we were hotly engaged. The ammunition failing, and no supply at hand, except a small quantity furnished by Maj. Gen. Gordon Granger, our men gathered their cartridges from the boxes of the dead, wounded, and prisoners, and finally fixed bayonets, determined to hold the position.

—*Report of Colonel Ferdinand Van Derveer,
Thirty-fifth Ohio Infantry, Commanding Third Brigade at Chickamauga, Georgia*

Ferdinand Van Derveer and Henry Van Ness Boynton scouted the battlefield. This time, however, they were not in danger of losing their lives. No Minié balls whizzed past their heads, no hostile troops stood behind cannons in preparation to fire artillery rounds and no dead or dying soldiers covered the now peaceful ground of Chickamauga. A quarter of a century had passed since the pair had witnessed the abandonment of the field by the Army of the Cumberland in its retreat back to Chattanooga. The man who had kept the defeat from turning into a complete disaster, George Thomas, was now dead. So, too, was Braxton Bragg, the commanding general of the Confederate forces. Nature slowly reclaimed the features of the battlefield itself. But the memories of the survivors remained, though they, too, were slowly diminishing each year as veterans from both sides passed away.

Van Derveer, a colonel during the Battle of Chickamauga, led the Third Brigade of the Third Division during the fierce fighting. He was

A Brief History of Catoosa County

born in Middletown, Ohio, on February 27, 1823, and practiced law there until the Mexican War broke out. Leaving his practice, he joined the First Ohio Volunteers and by the end of the war had risen to the rank of captain. Returning home after the war, he resumed the practice of law, even serving a number of years as sheriff. When the Civil War began, Van Derveer organized the Thirty-fifth Regiment, Ohio Volunteer Infantry, and became its colonel. He and his men fought at Mill Springs, Stones River, Chickamauga and Missionary Ridge. By the end of the war, he had risen to brigadier general. Afterward, he returned home and served as a judge.

After Van Derveer assumed command of the Third Brigade, Boynton, a lieutenant colonel, served as the leader of the Thirty-fifth Ohio Infantry, which made up one of the four regiments under Van Derveer's command at Chickamauga. Boynton was born in West Stockbridge, Massachusetts, on June 22, 1835, but he grew up in Ohio and graduated from Woodward College in 1854. He went on to the Kentucky Military Institute and graduated in 1859. His actions at Missionary Ridge earned him the Medal of Honor. After the war, Boynton returned home, married Helen Augusta Mason and became a newspaper correspondent and author.

The two former comrades in arms now briefly relived one of the harsher moments of their contribution to their nation's history. At Chickamauga, the Thirty-fifth Ohio suffered among the highest causality rates during the battle—virtually half of the entire regiment were killed, wounded or captured. As they toured the battlefield that day in May 1888, a Sunday, they remembered their fallen comrades and decided that others should, too. They determined that steps should be taken to preserve the site as a military park in commemoration of the actions that had taken place there. Boynton later described the scene:

> *Then—thinking of our Union lines alone—we said to each other: "This field should be a western Gettysburg—a Chickamauga memorial"… "Aye, it should be more than Gettysburg, with its monuments along one side alone; the lines of both armies should be equally marked."*

Though the idea of a military park was not new, the honoring of each side was. As early as 1864, the Gettysburg Battlefield Memorial Association set out to preserve portions of the nation's bloodiest battlefield. But Chickamauga would be different. Whereas Gettysburg only had Union monuments and markers, Chickamauga would represent

both the North and the South. Boynton described the creation of the park as a project

> *based upon the belief that the time has fully come when the participants in the great battles of our civil war can, while retaining and freely expressing their own views of all questions connected with the war, still study its notable battles purely as military movements.*

At this time, Boynton was the Washington correspondent for the *Cincinnati Commercial Gazette*. In a series of articles, he introduced his plan to readers, but specifically aimed his ideas at his former comrades. He called for the preservation of Chickamauga—this "Western Gettysburg," as he termed it—to honor the service of all who fought and died there. In September 1888, Boynton joined other members of the Society of the Army of the Cumberland in Chicago at their nineteenth reunion. There they agreed to take steps to preserve the battlefield. Rosecrans, who had commanded the Union forces at Chickamauga, appointed a committee to move the idea forward and included Boynton among his choices. This committee, the Chickamauga Memorial Association, gathered in Washington, D.C., on February 13, 1889, and met with Rosecrans and five former Confederate generals (William B. Bate, Alfred H. Colquitt, Edward C. Walthall, Joseph Wheeler and Marcus J. Wright). Also present was Captain Sanford C. Kellogg, a nephew of George H. Thomas and veteran of Chickamauga and the Chattanooga campaign. Kellogg, sent to Chickamauga by the War Department the previous November, had met with former Civil War officers in an effort to correct mistakes in government maps of the battlefield. Kellogg's corrected maps would prove invaluable for the coming task.

The former Confederates agreed to the idea of a park, and the parties formed the Joint Chickamauga Memorial Association. They met in Chattanooga in September 1889, during the reunion of the Society of the Army of the Cumberland. Many spoke at the gathering, and the whole point of the park was made clear—to honor both Union and Confederate soldiers. Rosecrans perhaps summed up their goal best when he said that the monuments in memory of the men who fought and died there should be placed "without criticism and with rather the feeling of comradeship." The healing of old wounds had begun.

Creating the Park

Boynton remained a key factor in moving the idea of the park forward. Though not a member of Congress himself, he called upon numerous friends in Congress to help him devise a bill that would lay out the association's plan. Once completed, Charles H. Grosvenor, who had also served in the Union army at Chickamauga, introduced the bill on the floor of the House in May 1890. Once introduced, it moved quickly through Congress. From committee to the floor of the House—where the measure (Bill H.R. 6454) passed in just twenty-three minutes—it then made its way to the Senate, where it passed without opposition. Both Houses were full of Civil War veterans, and seven senators had fought at Chickamauga.

On August 19, 1890, President Benjamin Harrison signed into law the act establishing a "National Military Park at the battle-field of Chickamauga." A veteran of the Civil War himself, Harrison served under Sherman during the Atlanta Campaign and left the army as a brigadier general. His signature officially created the park. Congress appropriated $125,000 for the task, and the War Department would administer the park, but the actual implementation of the plan itself proved an enormous undertaking. Georgia and Tennessee still had to cede the approach roads. The lines of battle remained to be determined. Design and construction of monuments and other structures still lay in the future. Further increasing the difficulty of the project was the fact that the park would encompass not only Chickamauga, but portions of Chattanooga, including Missionary Ridge and Lookout Mountain sites, as well. And the acquisition of the land itself, to say nothing of tree and undergrowth removal, loomed as perhaps the most challenging task of all.

Nor, despite the apparent ease with which the idea of the park passed through Congress, was there a lack of disagreements or resistance to the plan. Some didn't like the thought of representing both sides. Ohio's *Scioto Gazette* claimed that it was a land-profiteering scheme and further derided the idea to have "Rebel Monuments" on the battlefield as an insult to Union soldiers. Arguments also erupted over the placements of monuments. Kellogg protested the changes that several regiments made to locations he believed he had already pinpointed.

Obtaining the land itself proved a complicated task. A nearby railroad, fruit and vegetable farms and coal and iron ore deposits existed, and all contributed to increase the value of the property. Additionally, some two hundred parties had some form of claim to the land (many by way of inheritance or through informal trading, without any clear deeds). The

The Civil War and Its Aftermath

commission dealt with them all and settled the ownership status of each parcel before making a purchase. Many concerned landowners, aware of what was going on, demanded much more than the land was actually worth. Condemnation, however, eventually secured the land.

An Event "Without Parallel"

By the spring of 1892, four years had passed since Van Derveer and Boynton initially conceived the idea for the park. Though still not complete, Secretary of War Stephen B. Elkins decided to allow the first visitors into the park. With the permission of the park superintendent, they could camp in designated areas. They could also hire civilian tour guides to lead them over the terrain. Another three years passed, more land was obtained and the various states (twenty-eight in all) whose troops had served at Chickamauga decided upon designs for, built and then placed their monuments.

Confederate veteran Sergeant J.J. Dackett, wearing his hat with a bullet hole from the Battle of Chickamauga, revisits the battlefield after the establishment of the park. *Courtesy of the Library of Congress, LC-DIG-npcc-28219.*

A Brief History of Catoosa County

The formal dedication of the Chickamauga and Chattanooga National Military Park was set to take place on September 18 and 19, 1895—the thirty-second anniversary of the battle and seven years after Van Derveer and Boynton first conceptualized the park. Van Derveer, who died on November 5, 1892, did not live long enough to witness the dedication. But he had survived long enough to see his and Boynton's idea become a reality, if not yet a completed one. Boynton was appointed a historical aide shortly after the act creating the park was signed, and he enthusiastically supported its development. His sensationalized columns appeared in numerous publications, including the popular *Harper's Weekly*, and missed no opportunity to promote the coming dedication. Of the event, he wrote that it "is without parallel in the world's history."

Perhaps Boynton was not, by too much, exaggerating the grandness of the event. The guest list included President Grover Cleveland and his cabinet, members of Congress and the Supreme Court and the governors of all the states (there were thirty-eight at the time). The general public was also invited. Completing the guest list, of course, were the men who had fought there thirty-two years before. Ultimately, the president was unable to attend.

The ceremony began on September 18 with the dedication of the monuments already dotting the landscape of the park. There were only eight at the time; those represented included the states of Michigan, Missouri, Ohio, Illinois, Minnesota, Indiana, Massachusetts and Wisconsin. The Society of the Army of the Cumberland had decided to hold its reunion during the dedication. Ten thousand strong, its members met that evening and welcomed not only other Union soldiers, but Confederate veterans as well.

At noon the next day, forty thousand gathered on Snodgrass Hill, the site where Thomas had saved the Union army from disaster, for the dedication of the battlefield itself. An artillery salute opened the proceedings. The principal speakers, former Union Major General John M. Palmer and former Confederate General John B. Gordon, then spoke. Finally, the attending governors, fifteen in all, delivered brief speeches.

The following day, September 20, officials dedicated the remaining portions of the park: Missionary Ridge, Lookout Mountain and Chattanooga. Former Lieutenant General James Longstreet spoke that evening to attending survivors of both the Army of the Potomac and the Army of Northern Virginia.

The dedication concluded, and the Chickamauga and Chattanooga National Military Park officially opened. But the work to fully establish the park continued. More monuments were in the works, and more roads

remained to be built. In 1918, Congress made its final appropriation for the development of the park.

In 1897, Boynton, who first served as a historical aide at the park, became the chairman of the committee that oversaw its continuing development. He returned to active military service a year later as a brigadier general during the Spanish-American War, but he continued his duties at the park. He held his position as chairman until he died on June 3, 1905. Buried at Arlington National Cemetery on June 7, comrades from the Army of the Cumberland attended his funeral, as did President Theodore Roosevelt.

The establishment of Chickamauga served as the model for the development of future parks. Shiloh and Vicksburg soon followed, and more were to come. On August 10, 1933, the Department of the Interior assumed from the War Department the responsibility of administering the park. Now under the direction of the National Park Service, the Chickamauga and Chattanooga National Military Park became part of a network of historical parks and national monuments that its own founding had helped create.

But for more than a quarter of a century, the park remained under War Department control. Given this fact, it is perhaps not surprising that the battle and subsequent development of the park also served to lead the area to further military use. In 1902, Georgia ceded even more land and included in the very language of the bill an allowance for military posts and training:

> *Be it enacted by the General Assembly of Georgia, That the jurisdiction of this State is hereby ceded to the United States of America over any lands situated in the counties of Walker, Dade and Catoosa, in this State, adjacent to or in the vicinity of the Chickamauga National Military Park, which may be hereafter acquired by the United States for park purposes, or for the purpose of military posts, or for camps of military instruction, or for the purpose of erecting Confederate and Union monuments and historical tablets thereon.*

The 1863 impetus of the park became but the first segment of the military history of Catoosa. As the post developed, growing and shrinking as military demands warranted, soldiers who trained there would go on to fight in the Spanish-American War, World War I and World War II. But as the twentieth century dawned, few as yet suspected not only the enormous costs in resources and human life, but also the tremendous shifts in social and traditional values that the coming years would bring. Fort Oglethorpe became a microcosm of those changes.

PART III

ENTERING THE TWENTIETH CENTURY

CHAPTER 10

A NEW MILITARY POST

As we are united in life, and they united in death, let one monument perpetuate their deeds, and one people forgetful of all asperities, forever hold in grateful remembrance all the glories of that terrible conflict which made all men free and retained every star on the nation's flag.

—Inscription on the Kentucky Monument at Chickamauga, with which, purportedly, Theodore Roosevelt was so impressed that he had an aide write it down

In 1898, the powers in Europe were still masters of the world, controlling colonial empires that stretched around the globe. Otto von Bismarck died that July, and twenty years later—when World War I ended after ten million had died—the empire he unified lay in ruins. From its ashes would ultimately rise the Nazis and an even ghastlier conflict.

That year in America, the U.S. government annexed Hawaii. The country's largest city, New York, annexed land from surrounding counties and formally sectioned itself into the now familiar five boroughs of Manhattan, Brooklyn, Queens, the Bronx and Staten Island. Henry Ford completed his second car, an improvement over his first Quadricycle Runabout. Theodore Roosevelt, then assistant secretary of the U.S. Navy, was about to see the improvements he had made to American sea power used in the Spanish-American War. The other colonial powers of Europe watched as Spain, an empire nearly half a millennium old, suffered a humiliating defeat at the hands of a nation barely a century old.

In Catoosa, the local economy was about to receive a stimulus, though most of the benefit made it to neighboring Chattanooga, as soldiers once

again trod over the county's soil. Unlike during the Civil War, however, they were not there to fight or to heal the wounds left by that fight. This time, the soldiers who flooded into Catoosa, briefly increasing its population more than ten times over, were there to prepare themselves for an overseas war. By the time the soldiers eventually and permanently left just over half a century later, the post at which they had served had hosted three sitting presidents (Theodore Roosevelt, William H. Taft and Franklin D. Roosevelt) and one future president (Dwight D. Eisenhower), German POWs, African American troops and, for the first time, female military personnel. National celebrities also visited the post, and MGM, the studio with stars like Greta Garbo and Clark Gable that had released such classics as *The Wizard of Oz* and *Gone with the Wind*, even filmed one of its war pictures at Fort Oglethorpe.

CHICKAMAUGA POST

Camp Thomas, founded in 1898, eventually became Fort Oglethorpe. Named in honor of General George H. Thomas, the camp developed as a response to the nation's need for military installations for the Spanish-American War. The destruction of the second-class battleship *Maine* earlier in the year had, despite the fact that there was no evidence Spain had anything to do with it, launched the nation's war fever into high gear. But another reason lay just under the surface of demands for revenge and the call to "Remember the *Maine!*" Manifest Destiny, the same impetus that had sent Major Samuel Ringgold and many later Civil War veterans to Mexico in 1846, again impelled the imperial ambitions of the United States.

At the outset of the war, the United States was not prepared for battle—not on land, at least. The army, approximately 25,000 strong, was scattered across the country at numerous posts. President McKinley called for 125,000 volunteers (later more than doubling it to 267,000), but training these men for combat would require time, money and facilities. The battlefield at Chickamauga, despite the damage it suffered as a result, proved a perfect spot for one of these bases, Camp Thomas, which served as a key training base and prepared seven infantry regiments, six cavalry regiments and ten batteries of artillery. In all, over 70,000 soldiers trained there for the Spanish-American War.

The conflict lasted less than four months, from April 25 to August 12, 1898. A resounding U.S. victory, the United States suffered only 385 killed in action, with a total number of casualties (including the wounded and those who died

Entering the Twentieth Century

from disease) numbering just over 4,000. Spain's defeat, however, was much more costly (over 50,000 died, mostly due to disease) and marked the end of its colonial empire. The U.S. victory, in contrast, marked the rise of the United States as a military power with global reach. Theodore Roosevelt and his Rough Riders gained lasting fame on San Juan Hill, which also helped further his political career. Camp Thomas, no longer necessary, soon closed, but its role during the war remained in the minds of army leaders.

Considering the state of the U.S. military at the outset of the war, despite its success during the conflict, army officials ultimately decided that the country needed permanent training posts. In 1902, just four years after they left, soldiers returned to Catoosa County. This time, considering the damage to the park area proper that occurred during the Spanish-American War, the government set up its new military base just north of the park. Chickamauga Post comprised just over eight hundred acres of barracks, stables, various support buildings, a hospital and a parade ground. The officers' quarters, which were built in the Renaissance Revival style that had spread to the United States from Europe and were situated on Barnhardt Circle with its prime view of the large parade ground, added an elegant appearance to the post.

President Theodore Roosevelt visits Chickamauga in 1903 to check on the progress at the post and to dedicate the Kentucky Monument. *Courtesy of the 6th Cavalry Museum.*

A Brief History of Catoosa County

Named in honor of the founder of the colony of Georgia, James Oglethorpe, Fort Oglethorpe was officially dedicated on December 27, 1904. Both the army and the National Guard used the camp for instruction and practice maneuvers, and several cavalry units, including the Third, Seventh, Tenth, Eleventh and Twelfth, at various times called the post home. General John J. Pershing, leader of the American Expeditionary Force to Europe, also briefly served at the post. Earlier in his military career, he had served with the Sixth Cavalry as well, a unit that would later figure prominently in the history of Fort Oglethorpe.

African Americans at Fort Oglethorpe

The first unit to arrive at the post for training in preparation for the Spanish-American War was the Twenty-fifth Infantry, an all–African American force in a still-segregated army. They played a key role in the war, and even though Roosevelt and his Rough Riders received the lion's share of the credit at San Juan Hill, the African American troops were critical to the American victory there.

Called "Buffalo Soldiers" by the Native Americans they had fought on the Western frontier, the Twenty-fifth Infantry formed in 1868 and became the first African American peacetime troops. Though the origin of their nickname is uncertain, there are several theories, variously claiming that, when injured or cornered, they were fierce like buffalo; their hair resembled the mane of a buffalo; or, when charging into battle, they kept their heads down and were, like a herd of stampeding buffalo, an irritable force. Whether Native Americans meant it as a complement or as a form of derision, the Buffalo Soldiers accepted the nickname as an honor, and their example, courage and determination lit the way for later African American military achievements.

Colonel Duncan Richart, commander of the post in 1942, spoke highly of the African American soldiers training under his command, calling them the "best group of recruits, black or white, I've ever handled." Speaking directly to the troops, he went on to exhort them to become "the kind of an outfit that will take a back seat to no one," and he praised their bearing and actions thus far in their training, assuring them that, with work, they would become great soldiers. And they did, though, as with African American contributions to America's previous war efforts, these actions often failed to receive the attention they deserved. Indeed, seven African Americans received the Medal of Honor for their bravery during World War II, but when the nation

Entering the Twentieth Century

Segregation remained in effect in the Armed Forces of the United States until after World War II. However, African American soldiers were still led by white commanders, as seen in this photo of marching instruction at Fort Oglethorpe. *Courtesy of the 6th Cavalry Museum.*

finally got around to recognizing them in 1997—over half a century after the war ended—only one remained alive to accept his medal.

Numerous other African American units would come and go throughout the years at Fort Oglethorpe, and, as will be discussed in greater detail in Chapter 12, not all of them were male.

World War I

As the twentieth century unfolded, events in Europe were steadily moving toward war. The assassination of the heir to the throne of the Austro-Hungarian Empire, Archduke Franz Ferdinand, and his wife by Serbian nationalist Gavrilo Princip ignited what Bismarck had, as early as 1877, termed a "Balkan Powder Keg," descriptive of the condition of the potential disaster Europe faced if the fuse were to be lit. On July 28, 1914—one month after Ferdinand's assassination—Emperor Franz Joseph of Austria-Hungary declared war on Serbia in retaliation. This set in motion a series of treaty guarantees in a system of alliances that would pull all of Europe

into a general war. Over the course of the next ten days, European powers drew their battle lines. First, Russia, as an ally of Serbia, mobilized its army. Germany, in turn, declared war on Russia, then France and finally Belgium as German forces invaded the small country in hopes of a quick victory. Great Britain, in response to the invasion of Belgium, declared war on Germany. Austria-Hungary then declared war on Russia.

By 1917, the year the United States entered the conflict, Catoosa County residents were steadily seeing more and more headlines concerning the conflict in Europe. In addition to general announcements, like the cost of automobile tags (between $3.00 and $6.00, depending on horsepower for cars or the tonnage for trucks) and the net assets of the Bank of Ringgold ($145,611.71 as of March 20, 1917), the *Catoosa Record* delivered war news from Europe, as well as reporting on the German submarine attacks on U.S. shipping.

On August 2, 1917, the *Catoosa Record* headlined a "Notice of Call and to Appear for Physical Examination." The draft was in full swing. Ninety names had been selected to fill Catoosa's initial quota of forty-five men (the government expected 50 percent to be exempted for dependent families, physical disability or other reasons, though an earlier announcement in the paper had warned that recently married men would not escape service).

American involvement was inevitable. Isolationism had kept the United States out of the conflict early on, but Germany's unrestricted submarine warfare finally forced the Americans to act. At Fort Oglethorpe, three camps were set up comprising some sixteen hundred temporary buildings: Camp McLean, Camp Greenleaf and Camp Forrest. Buildings, training areas and men spilled over onto the historic battlefield as they prepared for the war in Europe.

These camps each had a specific purpose. Camp McLean served as an officers' candidate school. Camp Greenleaf provided medical training, including surgery, plastic surgery, urology, psychology, ophthalmology, dentistry and oral surgery, among other specialties. Camp Forrest (named for Confederate cavalry officer Nathan Bedford Forrest) served as a training center for reserve officers.

Part of a soldier's training at the post included trench warfare, and for three months in 1917 First Lieutenant Dwight D. Eisenhower served as one of the instructors. Trenches covered much of Snodgrass Hill for training exercises. The *Catoosa Record* headlined on Thursday, May 3, 1917, "Snodgrass Hill a Busy Place" and went on to report that there was

> *rapid progress being made in the construction of officers quarters on Snodgrass Hill. Since the decision was reached to locate the officers' training*

Entering the Twentieth Century

This postcard depicts soldiers during an artillery-loading drill at Fort Oglethorpe. *Courtesy of the 6th Cavalry Museum.*

During World War I, Fort Oglethorpe's Camp Greenleaf served first as a medical training facility and then, after victory, as a demobilization center for returning troops. *Courtesy of the 6th Cavalry Museum.*

Soldiers busy digging up the post. *Courtesy of the 6th Cavalry Museum.*

camp on Snodgrass Hill, that section of Chickamauga Park has developed into a hustling city of activity. Thousands of workmen are busy building the houses and shaping the grounds and otherwise making preparations for the coming of the men who will be drilled as officers.

The economic impact and benefit was not lost on the *Record*, which noted that, "with the large number of soldiers located at the park and all the building and other work necessary, business in this section ought to boom."

Economic benefits aside, the costs to the park were high. Soldiers raided the woodland areas for the wood necessary to support these trenches, and other park features suffered obliteration during their construction. Such actions, in addition to the damage to monuments and roads, the refuse and human waste, caused friction within the War Department, which at this time controlled both the historic park and the active military post. But the needs of the nation, its war effort and concern and respect for the troops kept the complaints by park personnel to a minimum.

Fort Oglethorpe also served as one of four German prisoner of war camps within the United States. When the United States entered the conflict in 1917, spies, diplomats, merchant seamen (their ships captured in U.S. harbors after Congress declared war) and even certain German citizens living within the United States found themselves incarcerated at Fort Oglethorpe.

Entering the Twentieth Century

The Thursday, April 5, 1917 edition of the *Catoosa Record* ran the headline "Many See Interned German Sailors" and went on to report:

> *About four hundred brought to Fort Oglethorpe from Philadelphia Last Week—They don't seem to worry. Many people from all over the country visited Chickamauga Park and Fort Oglethorpe Sunday to see the interned German sailors which were brought there last week from Philadelphia. There are about four hundred prisoners, including several Chinese cooks, which were taken from German ships which were interned in eastern harbors of the United States.*
>
> *The prisoners seemed to be enjoying themselves in the barbed wire enclosure as much as anybody else. They spend their time reading, strolling on the campus, playing the phonograph, doing athletic stunts, etc. They do not appear to be worrying over the fact that the United States is on the brink of war with Germany.*
>
> *The Prisoners are all husky looking men, and carry themselves like trained sailors on duty. The officers keep themselves aloof from the enlisted sea men, and order them around just as if they were on the ship.*
>
> *A large number of German sailors have also been interned at Fort McPherson in Atlanta.*

Propaganda notwithstanding, the merchant seamen built and operated their camp themselves and were even given the option to work outside the camp. Those who did not choose this option received punishment and half food rations. As the war continued, hostility toward Germans grew. Fort Oglethorpe's prisoner population also grew, as flimsy charges led to more arrests, including detainment of prominent and wealthy Germans like Dr. Karl Muck, then conductor of the Boston Symphony Orchestra. In the middle of 1918, the government moved all of the merchant seamen to Fort McPherson, and Fort Oglethorpe retained largely cultural and intellectual elite captives. Independent Swiss inspections indicated that prisoners received good treatment and had access to adequate food, shelter and other basic needs. The remaining prisoners complained to the Swiss observers but, even in captivity, continued as best they could with the lives they knew. They staged musical and dramatic performances, established their own school and even printed their own newsletter (the profits from which they were allowed to keep and donate to poorer prisoners).

The camp even held female prisoners who, as the *Chattanooga Times* reported, kept busy "sewing and doing fancy work." In all, Fort Oglethorpe

held some four thousand German prisoners over the course of the war. In some cases, they remained captive even longer. Approximately three hundred did not receive their release until April 1920.

On November 11, 1918, World War I ended. The United States fared better than most other nations—out of a total of nearly ten million dead, the United States lost the comparatively small number of 116,708. Of the soldiers Catoosa County sent to Europe, six did not return: Roy W. Connor, Berton J. Keys, Wallace M. Lillard, Jesse J. Roberson, Thomas C. Williams and Terrell Wimpey.

The crisis past, park officials no longer felt the need to constrain their complaints and demanded that the damaged fields and monuments be repaired. Congress approved $65,000 for the restoration of the park. But even after the war ended and activity at Fort Oglethorpe declined, the military still used the park for training and other purposes. Camp Greenleaf became a demobilization center, and though the numerous buildings scattered throughout the area eventually came down, troops continued to use the parklands for training, parade fields, inspections and cavalry maneuvers. The Alabama Thirty-first National Guard Division Aviation Detachment even built an airstrip on parklands to assist in its training maneuvers.

Perhaps most contentious to park officials was the use of the park for recreational purposes. The needs of the military for training sites during wartime were one thing, but using the park as a playground was quite another. The park declined a civilian request to hold a race there in 1911, though the Boy Scouts were permitted to use the park as a campsite in 1913. There was even a golf course upon the park grounds. When the Department of the Interior took over control of the park, it made attempts to limit the use of the park for such purposes. It was unable to get rid of the golf course until the post officially closed in 1946, but it did successfully restrict the course's growth, forbidding the army from extending it onto Snodgrass Field.

During the years between World War I and World War II, many soldiers from a diverse range of outfits would come and go through Fort Oglethorpe. But after returning from World War I, one military unit would make Fort Oglethorpe its permanent home. With them, they would bring to Catoosa County—despite the economic hard times that still held sway over much of the South—a sophisticated, even polished, lifestyle of social events, polo matches and equestrian competitions that would draw crowds from the larger and more urbane Chattanooga. This unit had fought all over the world, but for the next twenty-three years the Sixth Cavalry would call Fort Oglethorpe home.

CHAPTER 11

THE SIXTH CAVALRY

The traditions of the Old Army and the duties of the hour were our creed.

—*General John J. Pershing to the Sixth U.S. Cavalry*

Though many different cavalry units were posted at Fort Oglethorpe, the one most closely associated with the post, and which stayed there the longest, was the U.S. Sixth Cavalry (the "Fighting Sixth"). The unit originally formed in Pittsburgh, Pennsylvania, as traditional cavalry after Abraham Lincoln made his second call for volunteer troops on May 3, 1861. But the Civil War was the last major conflict in which units of horse-mounted soldiers proved viable. An ancient method of warfare, it faced numerous challenges from newer technology that had yet to develop countermeasures to cavalry's benefit.

The word "cavalry" originates from the French *cavalerie*, though the military application of men mounted on horses antedates both the French vernacular and the language from which it is derived (Latin). As we understand the concept today, the first true cavalry probably originated in ancient Egypt during the rule of Ramesses II (possibly the pharaoh during the Israelite Exodus). Its speed and mobility proved vastly more effective than regular infantry forces for a variety of tasks. Persia, Greece, Rome and other powers of antiquity made use of cavalry. Highly skilled mounted forces aided in the conquests of Alexander the Great. Later, the Mongol warrior Genghis Khan used mounted archers—trained to fire at a gallop with lethal precision—to terrorize and conquer portions of Asia and

Russia. The use of firearms changed cavalry tactics and would ultimately, with the advent of repeating and, later, automatic weapons, change the cavalry itself. Modern cavalry units are armored or, functioning as air cavalry, use helicopters.

THE SIXTH BEFORE FORT OGLETHORPE

When the Sixth Cavalry formed, the technological improvements of better and faster-firing weapons were already impacting its effectiveness, but it nevertheless played a significant role during the Civil War. One of its principal duties in this era was to provide intelligence on enemy troop movements and strength—critical information that often meant the difference between victory and defeat. The Sixth and other cavalry units were also used offensively (in direct attacks, raids or by harassing retreating enemy troops), as well as defensively (to protect their own army's retreating troops).

The Sixth was originally designated the Third Cavalry, but in August 1861 it was renamed the Sixth and has remained so ever since. Volunteers included men from Pennsylvania, Ohio and the western part of New York, and they trained throughout the remainder of 1861. Attached to the Army of the Potomac, the Sixth comprised 34 officers and 950 men. They served with distinction and fought in such well-known Civil War battles as Antietam, Fredericksburg, Chancellorsville, the Wilderness and Petersburg, among others. The Sixth was also present when Lee surrendered to Grant at Appomattox.

Ordered west only six months after the Civil War ended, the Sixth spent the initial period of its new assignment as part of the force charged with maintaining order in the Fifth Military District. This district, set up by Congress as part of the Reconstruction plan, comprised both Louisiana and Texas, with General Phil Sheridan in command.

The men of the Sixth first set up camp in Austin, Texas, where they remained until August 24, 1868, when they were moved to Fort Richardson, near present-day Jacksboro, Texas. Initially, the Sixth focused on suppressing local crime. According to William H. Carter, a captain in the Sixth:

> *The duties falling to the officers and men were of the most dangerous and varied kinds. After the close of the Rebellion the country was overrun with desperadoes and outlaws who were even worse than the hostile Comanches, and the officers and men were continually called upon to guard the courts*

of justice, to assist revenue officers, aid in executing convicted criminals, supervise elections, pursue outlaws and murderers, and in general to institute lawful proceedings where anarchy reigned. Many soldiers were assassinated for their devotion to law and order, and nothing but incessant vigilance and unflinching courage, prevented the guerrilla community from running the border counties of the State.

The cavalry's first encounter with Native Americans occurred at Buffalo Springs on July 21, 1867. Though the records only note "Indians," it is possible that this first battle involved the Kiowas; however, it's more likely that in this engagement the Sixth fought the Comanches. Most of the rest of the Sixth's activity during its quarter century of service in the West concerned fighting Native Americans—the previously mentioned Comanches and Kiowas, as well as the Cheyennes, Sioux and Apaches. The Sixth protected settlers from Native American reprisals against encroachment into their lands, fought wars against the various tribes and even captured Geronimo. And it would also play its part in helping to bring an eventual end to armed resistance, if not complete resistance, by Native Americans.

On September 30, 1886, John J. Pershing, recently graduated from West Point, was assigned to the Sixth and stationed at Fort Bayard, in the New Mexico Territory (statehood was still more than a quarter century away for New Mexico). In late 1890, the Sixth received orders to proceed to South Dakota in response to a threatening Sioux uprising. The cavalry arrived on December 9, 1890, and, twenty days later, took part in putting down the Sioux uprising. Though the Seventh Cavalry received the order to round up the Sioux, the Sixth played a role in what came to be known as the Wounded Knee Massacre.

Wounded Knee proved to be the last Sioux uprising and also proved to be one of the last of any Native American tribe's attempts at armed resistance. By this time, the various original peoples of America had (or soon would be) assimilated and now lived on reservations, where they watched their way of life live on only through histories or conscious efforts to preserve as much of their culture as possible. The Sixth was only one of many military units in a long line of "Indian fighters" that extended back well before the Cherokees were forced out of Georgia. The successive wars, broken treaties and relentless pursuit of land reduced the Native Americans to the point where the need for units like the Sixth, as said "Indian fighters," was rapidly diminishing. They stood near the end of a centuries-long conflict that, though Native Americans would later be

popularized by Hollywood as alternately noble or savage and as victim or victimizers, effectively ended so many cultures and ways of life.

However one interprets the treatment of Native Americans by the United States, the Sixth Cavalry's role in American military history was, in a sense, only just beginning. Though its next few assignments were relatively short in nature, it nevertheless played an important part in all but one of them. When the Spanish-American War broke out, the Sixth received orders to depart for Cuba, where, along with the Buffalo Soldiers and Theodore Roosevelt and his Rough Riders, its men charged up San Juan Hill. The Sixth's next assignment sent it halfway around the world to China. There, it served as part of a coalition including British, French, German, Japanese and Russian forces assembled to rescue over thirty-five hundred besieged Westerners and Chinese Christians during the Boxer Rebellion. On August 14, 1900, this force broke the siege of the anti-foreign Boxers, and the men took in the sights, including the Ming Tombs and the Great Wall. In 1901, the Sixth moved southward into the Pacific to put down the insurrection in the Philippines. In 1910, Pershing again joined with the Sixth Cavalry as the leader of the Punitive Expedition (officially known as the Mexican Expedition) to capture the revolutionary turned bandit Pancho Villa. The Sixth served as one of the main columns of Pershing's force and pushed four hundred miles into Mexico in an effort to put an end to Villa's raids into the United States. The expedition lasted eleven months, throughout which Villa evaded capture, but he never again attacked the United States.

While Pershing pursued Villa, World War I raged in Europe. When the expedition officially ended, the Sixth returned to the United States only to receive orders to proceed to Europe. It sailed on March 16, 1918, aboard the *Adriatic* for France. According to the Sixth's own pocket history, "It was in France that the Sixth US Cavalry, one of the fightin'est Regular Army units in the world, received a bitter pill to swallow—it was relegated to rear echelon security duty." On November 11, 1918, the armistice officially ended the war before the Sixth ever saw combat.

The Sixth at Fort Oglethorpe

With the supposed "war to end all wars" over, the Sixth briefly remained in France, stationed in Gievres and Vendome, until June 29, 1919, when it returned to the United States. Its new home, the longest stint at a single location in the regiment's history, was Fort Oglethorpe. Though the days that the Sixth

were stationed there were comfortable compared to its earlier history, they nevertheless proved to be the most profound. The changes to come, hinted at during the Civil War, did not apply to the method of "Indian fighting" on the frontier. But it had become increasingly clear that cavalry, in the face of technological improvements, would face greater and greater challenges to its continued viability. Airplanes, armored vehicles, machine guns and other accoutrements of war called into question not merely the role that horse-mounted men could play in combat, but whether they would even have a role at all. The regiment's stay at Fort Oglethorpe would answer that question.

In peacetime, these questions would keep; initially, at least. At its new home in northwest Georgia, the Sixth turned its attention to more tranquil pursuits. Though the men still drilled and held maneuvers, they also focused on ceremony, smartness of appearance and, as their pocket history states, becoming a "spit-and-polish organization." The sports field replaced the battlefield as the Sixth honed its equestrian skills for polo, horse tournaments, parades and troop reviews. Soldiers also played baseball and held numerous social events—such as concerts and dances—that attracted Chattanooga residents. For the Sixth, Fort Oglethorpe proved to be a plum assignment.

But the Sixth was not the only unit using the post. Throughout the period between World Wars I and II, Fort Oglethorpe still served as an important training center for reserve officers and Reserve Officer Training Corps

The Sixth Cavalry Baseball Team (taken sometime in the 1930s). *Courtesy of the 6th Cavalry Museum.*

(ROTC) trainees (Catoosa County Schools received their own Junior ROTC program in 1985). It also served as one of numerous locales for the military's month-long summer camps, the Citizens' Military Training Camps (CMTC). This program provided military training without requiring participants to commit to military service.

As of 1933, District C of the Citizen Conservation Corps (CCC), part of President Franklin Delano Roosevelt's New Deal program, was established at Fort Oglethorpe. The CCC's purpose included the conservation of natural resources such as timber, soil and water. It provided not only employment, but also training for unemployed men during the Depression. The Sixth assigned officers and men to help organize the CCC and provided training to its members.

From Grain to Gas: The End of an Epoch

Throughout the 1920s and 1930s, Adolf Hitler worked tirelessly to undermine the legitimate government of Germany and gather more followers to his Nazi Party. His speeches, the collapse of the German economy, the publicity generated by his Beer Hall Putsch and his writings in *Mein Kampf* all served to help boost his popularity. As Nazi representation in the Reichstag (the German equivalent of a parliament or congress) grew, so did Hitler's power. Finally, in 1933, German President Paul von Hindenburg agreed, against his better judgment, to appoint Hitler chancellor. At that point, war and all the other horrors perpetrated by the Nazis became virtually inevitable.

Hitler rapidly consolidated his strength, asking for and receiving from the Reichstag the power to create laws without their approval. He immediately initiated his plans for a racially pure German state, eventually sterilizing hundreds of thousands of "undesirables," who might produce less than perfect children, and also setting in motion the series of events that would lead to the Holocaust.

He also immediately set into motion the rearmament of Germany, specifically aimed at preparing Germany for four distinct and separate wars: first against Czechoslovakia, then Britain and France, then the Soviet Union and, finally, the United States. The Treaty of Versailles forbade the rearmament of Germany, but the European powers stood by and did nothing, a trend that would continue—and one that Hitler would take advantage of—as Germany grew more and more dangerous.

While the United States took no offensive action, this rearmament did not go unnoticed. The mechanized and armored forces Hitler was developing led

the U.S. military to consider both offensive and defensive measures against an army so equipped. Concerning cavalry, the question became: what place would horse-mounted men have against such forces? The army chose the Sixth to answer that question.

In the late 1930s, the Sixth reorganized to include a single horse squadron; a mechanized squadron made up of two scout car troops and a motorcycle troop; and a mechanized headquarters troop. These trained both individually and together as a team, field testing the Bantam car, the jeep and motorcycles, as well as the various duties of a cavalry unit performed with these vehicles—particularly reconnaissance—determining which worked best or if a combination of the two was optimum. By 1941, the answer was clear. Horse-mounted men simply could not keep up with their mechanized counterparts. The animals were strained in the attempt, and the coordination of working together proved too complex. When the Sixth later landed in Europe, it would deploy for combat for the first time in its history without a single horse.

Prior to the advent of mechanized vehicles, cavalry units depended upon horses, and parade field scenes of equestrian skill were common. As World War II loomed, Fort Oglethorpe served as the training grounds where horses were proved obsolete for the warfare unfolding in Europe. *Courtesy of the 6th Cavalry Museum.*

The night after the Japanese attacked Pearl Harbor, the Sixth received orders to guard public utilities in Georgia and Tennessee. Afterward, it moved from Fort Oglethorpe to Camp Blanding, Florida, where it underwent reorganization. Reequipped in preparation to leave for North Africa in late 1942, the Sixth had to postpone its departure after a German submarine attacked and sank the ship loaded with its supplies and equipment. The Sixth therefore did not leave until October 13, 1943, when it sailed from New York on the British ship the *Queen Elizabeth*. The regiment arrived in Northern Ireland five days later, with 1,556 enlisted men, 4 warrant officers and 78 officers.

The Sixth went on to serve with distinction during the war in 281 days of continuous combat. As part of General George Patton's Third Army, it performed important reconnaissance duties and served during the Battle of the Bulge, the breakthrough of the Siegfried Line and the crossing of the Rhine River and subsequent push eastward toward Germany. It also earned a Presidential Unit Citation for its service on January 8–9, 1945, in helping break German resistance that had effectively ground the Allied infantry advance to a halt. The citation concluded:

> *The Outstanding action of the Sixth Cavalry Group broke the back of the German resistance in the Harlange pocket, which had held up the Corps advance for a period of 11 days. The determination and indomitable fighting spirit of these courageous officers and men exemplify the finest traditions of the Military Service.*

After the war, the Sixth remained in Europe patrolling the German-Czech border, serving at schools and helping at orphanages that the war had filled. The Sixth also aided in the reconstruction of Germany and, in the only official recognition of an American unit by a German state, received in gratitude from Bavaria a silver plaque embossed with the Shield of Bavaria. The plaque currently hangs in the 6th Cavalry Museum in Fort Oglethorpe.

The Sixth finally came back to its new home, Fort Knox, Kentucky, in 1957. Since then, it has been deactivated, reactivated and moved around the country and the world to various headquarters from Maryland to Korea. It served in Operations Desert Shield and Desert Storm and, most recently, in Afghanistan and Iraq in fighting the War on Terror. The Sixth never again returned to duty at Fort Oglethorpe.

The post's military history, however, had not yet concluded. There, the United States learned that traditional cavalry had become obsolete in

Entering the Twentieth Century

modern warfare. As a military force, it had remained mostly the same for the last three millennia, but World War II put the horses, quite literally, out to pasture. The vehicles that replaced these traditional mounts, as well as all the other war materiel produced in American factories, came from the manpower supplied by women. For the first time, women entered the workforce in large numbers to replace the men who headed to Europe and the Pacific. But while Rosie the Riveter became one of the most recognized icons of this shift in the social fabric of America, she was nevertheless only part of the picture. Women had, after all, already been part of the workforce. What they had not done—at least not openly and with official government sanction—was serve their country in uniform. That would change at Fort Oglethorpe.

CHAPTER 12

THE WOMEN'S ARMY CORPS

They keep us jumping every minute. We're supposed to be free from 5 o'clock on, but tonight they made speeches beginning at 6 o'clock, then at 7 we had to clean the Orderly Room. I hear few Southern girls here. You can imagine all the Yankee accents piercing the air—painful to the ears.

—Aileen Kilgore Henderson, February 4, 1944,
in a letter to her parents about her first day at Fort Oglethorpe

From January 15, 1942, until August 9, 1945, the *Catoosa County Record* included in its banner atop its front page an appeal to readers to "Remember Pearl Harbor." Americans did remember Pearl Harbor, and they anxiously looked to the future for victory. In the process of winning the war, they would create a new future for not only the nation, but their individual lives as well. World War II reshaped the global order and placed America at the top as one of only two superpowers. But during the process, American society itself transformed and laid the groundwork for even further change in the coming decades. Many of these changes were positive, some were negative, but their cost was unquestionably high.

World War II claimed more lives and used more resources than any previous war in human history, dwarfing in scale all others. Sixty-one nations participated, and 1.7 billion people (75 percent of the total population of the world) either fought or played some form of support role. Approximately 25 million soldiers and another 30 million civilians died. Economically, the cost exceeded $1 trillion. The United States contributed the most to this

figure—$341 billion—and exceeded the next largest figure, which Germany bore, by nearly $70 billion.

To achieve this level of output, the United States had to do something it had never done before: call upon women for not just support roles as nurses or to sacrifice foodstuffs and other goods at home, but also to take an active and substantial part in arming the nation for war and keeping it supplied throughout the duration. It eventually became clear, however, that even so sweeping a change as women taking over the manufacturing and other jobs vacated by men who headed to Europe or the Pacific was not enough. The nation needed women in the military itself.

Women Auxiliaries

Over much public, military and congressional resistance, the bill creating the Women's Army Auxiliary Corps (WAAC) successfully passed in Congress on May 14, 1942. Supporters recognized the difficulty of waging a two-front war while maintaining the production of a stream of war materiel not only for U.S. needs, but the Allies' needs as well. Those opposed to the WAAC cited everything from the decline of both masculinity and birthrates to questioning who would take care of homemaking chores. Some men realized that their desk jobs might be taken by women and worried that this would send them from the safety of those desks into combat—and they proved correct in this assumption. But despite this opposition, the bill passed by a large margin in the House—249 to 86 votes. It did not fare as well in the Senate, but still passed by 38 to 27 votes. President Franklin D. Roosevelt signed it into law the next day.

Congresswoman Edith Nourse Rogers of Massachusetts introduced the bill as early as 1941. Rogers, the sixth women elected to Congress, won her husband's seat after his death in 1925. She served for thirty-five years in the House of Representatives, to date the longest period of service by any woman in either the House or Senate. She championed veteran affairs, opposed child labor, believed in equal pay for women for equal work and was one of the first members of Congress to speak out against Hitler's mistreatment of the Jews.

Though women had officially served in the military as early as 1901 (as members of the Nurse Corps), they were actually only civilian employees. The women who served during World War I received better treatment from the navy, Marine Corps and Coast Guard, but the army treated women as

civilian contractors and provided no benefits. Rogers's intention in creating the WAAC was to ensure that women, who she knew would serve in some capacity if the United States did indeed become involved in the conflict then engulfing the world, be afforded the same legal rights and benefits as their male counterparts, a status members of the Nurse Corps did not enjoy. But before Pearl Harbor, her idea generated little interest.

As public support of the idea grew, however, the army—concerned with maintaining as much of the military status quo as possible—worked with Rogers on a compromise deal: WAACs would work with the army, not as a part of it, and would not be empowered to command men. In return, the army would provide WAACs with most of the basics it provided stateside male soldiers—food, uniforms, medical care, quarters and a salary. WAACs could serve overseas, just as male soldiers would, but, unlike them, women would not enjoy overseas pay, life insurance, medical coverage or death benefits, and, if captured, they were afforded no protection under existing international prisoner of war agreements. It was not everything Rogers wanted, but it was a start.

In addition to the aforementioned ground rules, women also had to meet basic physical and mental requirements. To join the WAAC, a woman had to be between the ages of twenty-one and forty-four (later expanded to between twenty and forty-nine), have "excellent character" (two character witnesses from businessmen or professionals were required), pass a physical

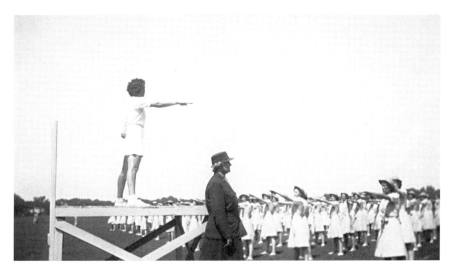

WACs in physical training exercises at Fort Oglethorpe. *Courtesy of the 6th Cavalry Museum.*

examination, be of average height and weight (not less than 100 or more than 171 pounds), stand not less than five or greater than six feet tall and have at least two years of high school or pass a multiple choice mental alertness test. They also had to be U.S. citizens and could have no dependent children under the age of fourteen. Training lasted four weeks initially, but later increased to five and then six weeks by 1944.

Initially, five WAAC training facilities opened around the country. Des Moines, Iowa, opened first, and centers in Daytona Beach, Florida; Fort Oglethorpe; Fort Devens, Massachusetts; and Camp Rustion, Louisiana, followed. With the exception of Des Moines and Fort Oglethorpe, lack of sufficient recruitment closed all the WAAC facilities down by the end of 1943.

Enter the WAACs

The WAACs would ultimately assume clerical and support roles within the military structure and free up men for combat duty. Their training at Fort Oglethorpe and the other centers would prepare them not only for these jobs, but it would also assimilate them into a militaristic system much like the one that existed for their male counterparts. The post became the home

WAACs in review at Fort Oglethorpe. *Courtesy of the 6th Cavalry Museum.*

of the Third WAAC Training Center, but it wasn't exclusively its post. With the declaration of war, the army established an induction center for new draftees from Chattanooga and the surrounding area. When the WAACs arrived, they shared Fort Oglethorpe with this center, as well as the regular army personnel stationed there. By September 1943, only the five thousand WAACs and the induction center remained—all other males permanently stationed at the post had received assignments elsewhere.

Life at Fort Oglethorpe included physical training, marching, drills and instruction for whichever specific job their backgrounds and aptitudes suited them. In general, corps members could find themselves in training to be drivers, switchboard operators, clerks, typists, secretaries, cryptographers, photo interpreters, stenographers, translators, legal secretaries, telegraph and teletype operators, radiographers and more. Once they finished their training, most were assigned to stateside duty, but thousands served overseas and would help compile dossiers on German officers, follow troop movements and plan attacks—even D-Day—and some even followed the soldiers to Normandy, landing just over a month after the Allies had successfully driven the Germans from their positions to take over critical communication duties.

But it wasn't all work—not while in training at Fort Oglethorpe, anyway. In addition to maintaining their barracks, cleaning the orderly room and gas

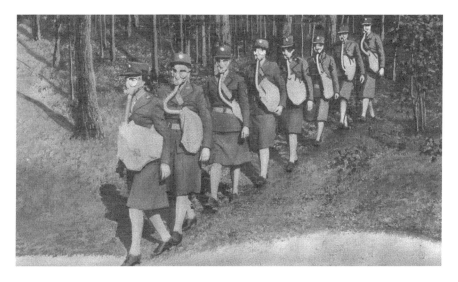

Though WAACs were not permitted to serve in combat roles, they nevertheless received training for a variety of possible wartime situations. *Courtesy of the 6th Cavalry Museum.*

drills, WAACs enjoyed all that life at the post had to offer. Though the heyday of the Sixth Cavalry polo matches and equestrian exhibitions was over, life at Fort Oglethorpe still offered dances, bingo, softball and concerts. The post also had two theatres showing the latest films of the day, including *Best Foot Forward* with Lucille Ball, *They Came to Blow Up America* with George Sanders and Anna Sten, *Girl Crazy* with Mickey Rooney and Judy Garland, *The Navy Comes Through* with Pat O'Brien and George Murphy, *Sahara* with Humphrey Bogart and *This Is the Army* with Ronald Reagan, to name but a few.

Many movies, as some of the above titles suggest, were wartime morale boosters with patriotic themes. A portion of one such film, Metro-Goldwyn-Mayer's *Keep Your Powder Dry*, was actually filmed at the post. Starring Lana Turner, Laraine Day and Susan Peters, the film's plot centered on three women who each join the WAACs. After their initial training in Des Moines, the three report to their new post, Fort Oglethorpe. MGM billed the film as a "Timely Tribute to the Women's Army Corps," and, at least in the scenes

Bing Crosby shares a laugh with the WAACs during his visit to Fort Oglethorpe. *Courtesy of the 6th Cavalry Museum.*

where the women were on duty, it proved a relatively accurate portrayal of life in the corps. It debuted in 1945 and moderately boosted corps recruitment.

This film wasn't the only brush with celebrity enjoyed by the WAACs. Other celebrities to visit the park included Walter Pidgeon, Al Jolson and John Payne. But the biggest Hollywood star to visit the post was Bing Crosby. Just three weeks before the premier of the film *Dixie*, in which he starred as the musical's central character, Crosby just happened to be visiting Dixie. On June 1, 1943, he performed at the Open Air Theatre at Fort Oglethorpe after a benefit golf match he planned to attend in Birmingham, Alabama, was canceled. His appearance was therefore on short notice, and after a brief rehearsal the show began at 8:15 p.m. A crowd of about five thousand attended. Crosby's performance included such popular songs as "Stardust," "You'd Be So Nice To Come Home To," "Dinah," "As Time Goes By" and "White Christmas." This last may seem an odd selection for a summertime performance, but "White Christmas" was the biggest hit of the previous year and went on to be the most popular song of Crosby's entire career. Even today, it remains one of the top five performed holiday songs. After the show, Crosby spent the night at the Read House in Chattanooga, Tennessee.

From WAACs to WACs

On July 3, 1943, the Fort Oglethorpe WAAC post news bulletin included the following announcement:

PRESIDENT SIGNS BILL TO MAKE THE WOMEN'S ARMY AUXILLARY CORPS A PART OF THE ARMY:

The President yesterday, 2 July 1943, signed the bill making the Women's Army Auxiliary Corps a part of the regular army, but Waacs will not be members of the Army until all administrative details are completed. Personnel of this Training Center will be notified when the privileges, such as free mailing, Government insurance, allotments, compensation and pensions, that are extended to the regular army have been extended to members of the WAAC.

BY order of Colonel BROWN:
HAZEL M. SMITH
3rd Officer, WAAC
Assistant Adjutant

In little over a year, the WAAC program had proven so successful that military leaders, initially restive to the thought of women as part of the military, actually asked for the authority to bring the WAACs into the army proper by dropping the "Auxiliary" and forming simply the Women's Army Corps (WAC). When Roosevelt signed the bill into law, WAACs received two choices: become a WAC or return to their former lives; 75 percent remained, while the others became civilians again.

On April 17, 1943, less than three months prior to his signing of the bill that created the WAC, Roosevelt had visited Fort Oglethorpe. According to park superintendent Charles S. Dunn, the WAACs were unaware that the president was coming. Assembled in front of the National Park Service headquarters (which today houses the park's Visitors Center), all they had been told was to be prepared for inspection. Roosevelt's motorcade arrived at eight thirty that morning to the booming of a twenty-one-gun salute. Accompanying the president in his convertible were Hobart B. Brown, the

President Franklin Delano Roosevelt visited the Third WAAC Training Center in the spring of 1943. In this image, FDR arrives for his tour in front of what is today the park's Visitors Center. *Courtesy of the 6th Cavalry Museum.*

WAAC commandant at Fort Oglethorpe, and Colonel Oveta Culp Hobby, overall director of all WAACs. The approximately four hundred women present saluted as the WAAC band performed "The Star-Spangled Banner." After a brief inspection, during which the president greeted each officer, Roosevelt proceeded through the park to view memorials of America's most costly war.

There were a handful of Civil War veterans still alive; Roosevelt had even met some of them at the seventy-fifth anniversary commemoration of the Battle of Gettysburg five years prior to his visit to Chickamauga. Now, like Lincoln before him, Roosevelt was a wartime president, and as he rode over the soil of Catoosa County, where so many men had fallen (over five times the roughly sixty-five hundred causalities America would soon suffer on June 6, 1944, D-Day), perhaps he reflected upon his predecessor's words at Gettysburg—that "new birth of freedom"—and what his country, its allies and the latest generation would have to suffer to bring rebirth to freedom across Europe and Asia.

President Franklin Delano Roosevelt reviews the WAACs from his convertible on the parade field at Fort Oglethorpe. *Courtesy of the 6th Cavalry Museum.*

When the president and his party returned to the post, three thousand WAACs assembled on the polo field for review, with the picturesque homes of Barnhardt Circle visible in the background. As the WAAC band began to play and the women marched in formation before their commander in chief, Roosevelt looked on and was evidently pleased with the review. Three days later, in an April 20, 1943 commendation that lauded the WACCs' "magnificent demonstration of...soldierliness, military bearing and marching," Brown praised the women of the Third WAAC Training Center and added: "I cannot quote the President, but I am sure I reflect his sentiments when I tell you he was amazed and greatly pleased."

A Fundamental Shift

"Our women are serving actively in many ways in this war, and they are doing a grand job on both the fighting front and the home front," Eleanor Roosevelt observed in January 1944. But they were doing more than that—they were also making history. On April 22, 1944, Lieutenant Colonel Elizabeth C. Strayhorn became post commander at Fort Oglethorpe, the first woman to ever hold command over a U.S. military post. And the WACs themselves were something new in American history. Men had congregated before en mass for previous wars, but women, mostly confined to social circles, church gatherings and their families, had hitherto never joined together in such large numbers and with such a rigid hierarchy as a military environment demands. And, much like the men who served together, many WACs formed friendships that would last for the rest of their lives. In all, some 150,000 women served in the WAAC and WAC and not only broke down numerous barriers for women in the culture of the 1940s, but also laid the groundwork for the changes to come.

African American women also served at Fort Oglethorpe and began to break barriers of their own. Indeed, World War II marked the first time any significant number of African American women aided the United States in wartime. Officials allowed only eighteen into the Army Nurse Corps during World War I, but roughly six thousand would serve as WACs during World War II.

Most African American women were specifically recruited near the war's end for general hospital duties, but one unit, the 6888th Central Postal Directory Battalion, became the only African American WACs to serve overseas. The women selected to go—approximately 855—received

orders to report to Fort Oglethorpe. There they received technical training, were taught how to march, learned how to recognize enemy aircraft, ships and weapons and slogged through the tougher aspects of military training: gas mask drills, crawling under barbed wire, climbing, endurance marches and more.

Though the rigorous training may have surprised many of the women of the 6888th, it was not the only unexpected thing they found at Fort Oglethorpe. Upon their arrival, they were surprised to find that the post itself did not segregate them from the other women. On this point, the WAC was ahead of the curve compared to the regular army, which did not desegregate until President Harry S. Truman issued Executive Order No. 9981 in 1948, officially desegregating the Armed Forces of the United States forever. Still, the new recruits received warnings that the status quo of segregation remained in effect off base.

The actual duties of the 6888th in Europe comprised sorting through mail that had been piling up for the troops in the field. The WACs' first assignment was in Birmingham, England, where they were assigned the task of sorting through a backlog of undelivered mail that was, in some cases, over a year old. They found an entire building stuffed with mailbags and packages stacked to the ceiling awaiting them. The logistical problems of delivering mail, especially after D-Day and the Battle of the Bulge, grew more complex, as the usual personnel who handled mail processing were reassigned to more critical roles. Some of the damaged mail had barely legible addresses. Many packages, containing gifts such as cookies and other sweets from loved ones on the homefront, reeked of rotting foodstuffs. Rats ran rampant and were often found dead within the packages containing such sweets. The WACs repackaged any and all items not spoiled by vermin, insects or time and forwarded them on. Observers claimed that the job would take six full months, but the 6888th broke all previous mail redirecting records and processed over eight thousand pieces of mail per hour. The women completed the job in just three months, cutting the original estimate in half.

While there may have been more glamorous duties, the 6888th nevertheless knew it was being evaluated, and not just by the military, but also by Americans back home. Further, even though it was not an exciting job, it boosted the morale of the troops. Soldiers, and not just troops in World War II, had witnessed their comrades—men who had seen death and dealt death; men who were battle hardened, tough-minded and wore serious countenances with steely eyes—walk away empty-handed at mail

A Brief History of Catoosa County

call, inconsolably dejected, some even moved to tears because they received no letter from their father, mother, wife or sweetheart. The 6888th knew it was helping to encourage these men, and the women did their duty well, helping to chip away at not only Nazism and Fascism, but the racism back home as well.

From Military to Civilian

The WACs left Fort Oglethorpe in July 1945. Some fifty-three thousand women in all had trained there. As they left Fort Oglethorpe, the post, which had inducted soldiers at the beginning of the war, now began receiving them back home and processing their discharges. The greatest generation now had to get back to the business of living, and that it did. Returning to civilian life, many buried their uniforms, medals and other physical reminders of their experiences deep in their closets or attics. And while the nation would soon find itself embroiled in a new kind of war, a cold war, Catoosa County at least let slip its military ties into the past. The troops that had passed through Fort Oglethorpe after their return had become civilians again, and deemed too small by the latest military minds, Fort Oglethorpe itself traded

A postcard of the officers' quarters encircling the parade field on Barnhardt Circle. *Courtesy of the 6th Cavalry Museum.*

in its military designation for a civilian one. In 1949, it became the first new city in Georgia in twenty-five years, a ready-made town that the War Assets Department sold off by sealed bid.

Though the curtain drew to a close on over half a century of military life at Fort Oglethorpe, the original purpose of the park again reasserted itself. Only three other U.S. battlefields draw more visitors per year than the Chickamauga and Chattanooga National Military Park. Visitors go for the Civil War history, and that is all they now see, as no visible reminders remain on the battlefield of the later training and maneuvers that occurred there. The houses that served as officers' quarters, however, still surround Barnhardt Circle and the parade field where generations of Americans drilled, honing their marching or equestrian skills. The latter, like the post itself, is a bygone reminder of the fleeting nature of even the most seemingly permanent ways of life.

CHAPTER 13

THE REST OF THE STORY, ALMOST...

It is the hope of the author that some younger person, perhaps some one of her many pupils in History, will take up this work where she is laying it down, and within a decade or so add another chapter to the history of Catoosa. Let us remember that what happens today will be of interest 50 or 100 years hence, and if not written down will perish forever.

—Susie Blaylock McDaniel,
from the forward of the Official History of Catoosa County, *1953*

Many different people and powers have claimed the lands that encompass Catoosa: Paleo-Indians, the Mound Builders, Creeks, Cherokees, Spain, Great Britain, the United States, the Confederate States and the United States again. When the Cherokees—who controlled this area for a longer period of time than any other group—were forced from northwest Georgia, the area still lay somewhere between the greater sophistication of the Eastern United States and the wilder, harsher American frontier. When we think of going west today, we do not think of the border between Alabama and Georgia. But in the early 1800s, a settler seeking a better life for himself and his family farther "west" could have counted the gap among his possible destinations. True, Kentucky had numerous settlers, and New Orleans had existed since the late 1600s, but the explosion into the West as Americans traditionally understand it had yet to occur.

In 1860, this Western frontier had even reached the Pacific. Illinois, or perhaps the territories of Kansas or Nebraska, was still considered "parts

west," but pioneers could go all the way to California if they so desired. By then, Ringgold was a bustling shipping post and Catoosa County, not yet a decade old, held just 31 people per square mile within its borders. Of course, these days no one considers northwest Georgia as "parts west." The area is decidedly part of "the South," with all the historical, cultural and stereotypical concepts and beliefs that go along with that designation. During the time in which this shift from western "Indian" territory to quaint Southern community took place, the county's population continued to grow (the dip after the Civil War aside) to reach an estimate of 62,016 people as of 2006—just over 382 per square mile.

Today, Catoosa stands as the "Gateway to Georgia," first thanks to the Dixie Highway and currently to Interstate 75. Yet Ringgold remains much as it was when it was known as Crossroads: a small town and still a crossroads (the aforementioned interstate being the latest route of significance). True, there are more people, more businesses and a greater variety of places where travelers and locals may rest and eat than Richard Taylor's Inn or the amusements Catoosa Springs once offered. But the depot still stands, a constant reminder of the past and silent witness to the unknown numbers who passed through on trains, or nearby on foot, wagons or horseback by way of the Old Federal Road.

In 1995, then governor Zell Miller approved the purchase of Stone Church on behalf of Georgia, Catoosa County and the Catoosa County Historical Society. Renovated shortly thereafter, the structure currently serves as a museum administered by the historical society. The small church graveyard that lies behind it, invisible from the road, is dotted with headstones and markers, a handful with tiny American or Confederate flags placed nearby and others with birthdates extending back into the 1700s.

The Cherokees who were forced from Catoosa County nearly two centuries ago still live in Oklahoma. Richard Taylor lays interred there. Of the approximately 13,000 who survived the Trail of Tears, the Cherokee population has grown to over 300,000 today—over ten times the estimated number of Cherokees who lived in the Southeast when de Soto spread European disease into the New World.

On April 14, 1962, the General once again passed through Ringgold. On this trip, made in celebration of the one-hundredth anniversary of its capture, more than ten thousand people packed the town as the famous engine came to a halt in Ringgold. Each side of the track thronged with onlookers, as adults snapped pictures and young boys placed pennies on the track to create their own personal souvenirs. Attendees close enough to the

Entering the Twentieth Century

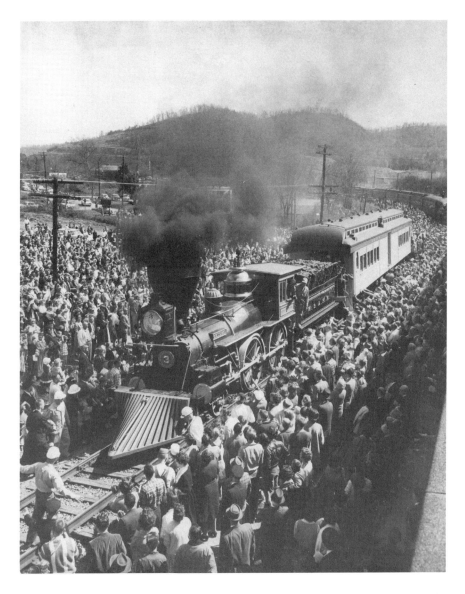

In 1962, onlookers celebrated the 100-year anniversary of the capture of the General as it passed through Ringgold. The old engine would go on to appear at numerous other events, but its traveling days were numbered. It last ran under its own steam in 1966 and came to its final stop on April 12, 1972—110 years after Andrews's Raid—at Kennesaw. *Courtesy of the State Library of Louisiana.*

A Brief History of Catoosa County

The Georgia Monument on the Chickamauga Battlefield at sunset. *Photo by Jeff O'Bryant.*

General stretched out their hands to touch the engine, briefly reaching into the past to link themselves with a small part of the conflict that ultimately proved to be the crossroads not only of American history, but of Catoosa as well.

Major Samuel Ringgold lays interred next to his brother, Cadwalader Ringgold, in Green Mount Cemetery in Baltimore, Maryland. After his death, the Philadelphian *North American* lauded him as "the soul of chivalry and honour...lofty as a patriot, beloved as a man," but it was not entirely accurate in its conclusion concerning the longevity of his renown. His memory, the piece concluded, "would be gratefully cherished so long as honour has a victory, freedom a hero, or his country a name." According to cemetery caretakers, few, if any, visitors ask for directions to his grave site. Instead, they mostly ask for the location of the unmarked grave of the cemetery's most famous, or rather infamous, figure: John Wilkes Booth. Given Ringgold's contributions and Booth's crime, this historic injustice is perhaps somewhat mitigated by the knowledge that it is the memory of Booth's victim, and not Booth himself, with which visitors seek to connect. Still, Ringgold lays largely forgotten in his final resting

Entering the Twentieth Century

The main entrance to Fort Oglethorpe, 1944. *Courtesy of the 6th Cavalry Museum.*

A Brief History of Catoosa County

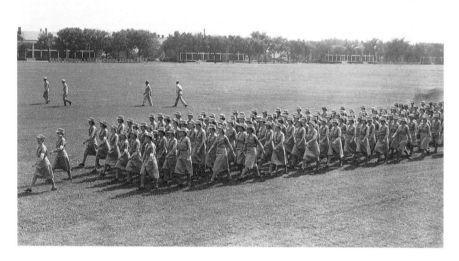

WACs in formation. *Courtesy of the 6th Cavalry Museum.*

place—an ignominious end for a man who helped to so greatly increase the territory of the United States, allowing the nation to truly stretch from the Atlantic to the Pacific Coast in the most obvious expression of Manifest Destiny.

The Chickamauga and Chattanooga National Military Park features approximately fifteen hundred monuments and markers. It draws nearly one million visitors per year and is outranked in visitation by only eight other memorial sites. From eighth down, they are the Minute Man National Historic Park in Concord, Massachusetts; Valley Forge; the USS *Arizona* Memorial in Pearl Harbor; and Gettysburg. The remainder are all located in Washington, D.C.: the Korean War Veterans Memorial, Vietnam Veterans Memorial, World War II Memorial and, at number one, Arlington Cemetery. Many visitors to Chickamauga come seeking to make contact with the Civil War history there. Most are unaware of the history of the post that followed. But its creation set a precedent, predating even Gettysburg's establishment as a military park under Federal control, and served as the model for all the other battlefield preservation initiatives to follow.

Fort Oglethorpe grew to become the largest town in Catoosa County. The first census to record the city's population occurred in 1950, noting 631 residents, as compared to Ringgold's 3,086. Today, its population is approximately 9,000, which is over three times the size of Ringgold. Many of the original structures at the post are now gone, though the houses of

Entering the Twentieth Century

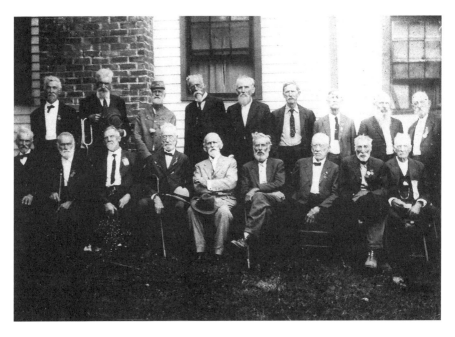

A Confederate reunion held at the First Baptist Church of Ringgold. *Courtesy of the Catoosa County Historical Society.*

Barnhardt Circle still survive. The Sixth Cavalry, lately reorganized, is now broken up into different squadrons, each with a different home base: Fort Carson, Colorado, for the First Squadron; Schofield Barracks, Hawaii, for the Second; Fort Lewis, Washington, for the Fourth; and Fort Drum, New York, for the Sixth.

Though the WACs left Fort Oglethorpe in 1945, they were not disbanded until 1978. Women now serve in the regular armed forces, performing all duties their male counterparts perform with the exception of ground combat. In Catoosa County, and at the other WAC posts, many began to realize what the WACs' success meant. So, too, did racial opinions, even in the Deep South, slowly begin to change as African American troops drilled and trained at Fort Oglethorpe and other bases across America, proving themselves both in training and in combat overseas.

Since its creation out of Walker and Whitfield Counties, Catoosa helped link Georgia to other states, experienced war, rebuilt and helped mend the rift between the North and the South. The men and women who received their training at Fort Oglethorpe helped their fellow countrymen change the world by not only ending the ambitions of the Nazis and imperial Japan, but

also lighting the way for the eventual integration of women into the army, as well as ending racial segregation. And its sons and daughters served America in later wars, such as Korea, Vietnam, Desert Shield and Desert Storm and, at the time of this writing, Afghanistan and Iraq.

But for Catoosa, the defining moment of the county's century-and-a-half chronicle is the Civil War. So much that followed—from the development of the park to the creation of the post—rose in the shadow cast by the events of 1861 through 1865. As the September 20, 1917 edition of the *Catoosa Record* headlined a "Red Letter Day for Ringgold," it went on to describe the "impressive" ceremonies in honor of Catoosa residents recently drafted for service in Europe. The ceremony also included Confederate veterans in the tribute. The Eleventh Cavalry Band from Fort Oglethorpe provided music, playing such patriotic tunes as "America" and "The Star-Spangled Banner" as an estimated fifteen hundred people gathered to honor the old veterans and wish the young soldiers well. After the women of the Red Cross presented their own hand-made "comfort kits" to the young men about to depart for war, the band struck up "Dixie." "This was the most solemn moment of the entire program," the story continued. "Many of the mothers, sisters and sweethearts in the audience were seen to shed tears." They wept not during "America," not during "The Star-Spangled Banner," but during "Dixie." Half a century after the fact, the memories of the Civil War remained strong.

Today, times have changed some. Despite efforts to keep the Confederate Stars and Bars flying over the Ringgold Depot, the town that was previously known by so many designations before honoring the memory of a single fallen American soldier now pays tribute to all its own who have served their country. Twice yearly, the City of Ringgold remembers their sacrifice with the Festival of Flags, a tradition that was begun in the 1970s by the local Veteran of Foreign Wars Post to honor deceased Catoosa County veterans. Before each Memorial Day and Veterans Day, volunteers from around the county gather to unfurl and line the streets with, at last count, over eight hundred American flags, each one representing a deceased Catoosa County veteran whose family has provided a flag for the tribute. The soldier's name—and the war in which he or she served—appears on the cross that anchors the flag to the soil of Catoosa County.

EPILOGUE

Up into the Hills is an effort to reveal connections, to show how life in Catoosa County was not only shaped by national and international events, but also how what happened in Catoosa sometimes played a part of its own, however small, in determining the final outcome of those faraway happenings. With that in mind, I have focused not on the minutiae of family histories and community events, but rather on the larger backdrop and where Catoosa fits into that picture. This volume, therefore, goes into some detail concerning the histories of peoples and events both before and after those people and events left their mark on Catoosa.

I have also taken pains to view the history of Catoosa objectively—a challenge, though not an impossible one, when you know so many people who experienced events about which you have only heard or read. As a little girl in the late 1920s and early 1930s, my grandmother, Louise, remembers seeing the cavalry pass by while they were away from the post on maneuvers near LaFayette. My grandfather, James Calvin ("J.C." to everybody who knew him), served in the Twenty-eighth Infantry Division and landed on Omaha Beach in 1944. Like so many veterans of that war, he did not often talk of his experiences. Home on leave, he was in Lafayette ready to depart for the Pacific Theatre when news of Japan's surrender broke. As the story goes, not having ready transportation, and his family unaware that he had not already left, he ran all the way home—about ten miles. An American flag now flies in Ringgold in his honor every Memorial and Veterans Day, one among the many in tribute to the veterans of Catoosa County who served in wartime. My father was among those who placed pennies on the track when

Epilogue

the General made its centennial trip along the route of the Andrews Raid, and he went overseas as one of the young Catoosa County men to serve in Vietnam. And my mother recalls, without any incident or hostilities, the first African Americans to attend Ringgold High School when it was integrated in 1966. As for myself, I seemed to have been born after all of the interesting events happened. But then, isn't that usually the point of view from one's own perspective?

BIBLIOGRAPHY

Allen, Felicity. *Jefferson Davis, Unconquerable Heart.* Columbia: University of Missouri Press, 1999.

Bates, Rod. "Gallant Maj. Samuel Ringgold's name still of household use." *Island Breeze Valley Morning Star.*

Black, Robert C., and Robert C. Black III. *The Railroads of the Confederacy.* Chapel Hill: University of North Carolina Press, 1998.

Boynton, H.V. *The National Military Park Chickamauga—Chattanooga: An Historical Guide.* Cincinnati, OH: The Robert Clarke Company, 1895.

Brandon, William. *The Rise and Fall of the North American Indians.* Lanham, MD: Taylor Trade Publishing, "A Robert Rinehart Book," 2003.

Catoosa County. *Georgia Heritage 1853–1998.* Marceline, MO: Walsworth Publishing Co., 1998.

Catoosa County Celebrating 150 Years. Ringgold, GA: Catoosa County News and Fort Oglethorpe Press, 2003.

Catoosa County News. "New Theory on Catoosa's First Settlers." February 25, 2004.

Bibliography

Clark, William H.H. *History in Catoosa County*. Self-published, 1972.

Cox, Jack F. *The 1850 Census of Georgia Slave Owners*. Baltimore, MD: Genealogical Publishing Company, 1999.

Cozzens, Peter. *Chickamauga Field Guide*. Bedford, NH: TravelBrains, 2002.

Crook, J.K. *The Mineral waters of the United States and their therapeutic uses: With an Account of the Various Mineral Spring Localities, Their Advantages as Health Resorts, Means of Access, Etc., to which is Added an Appendix on Potable Waters*. New York: PA Lea Bros. & Co., 1899.

Dana, Charles Anderson. *The American Cyclopædia: A Popular Dictionary of General Knowledge*. New York: D. Appleton and Company, 1873.

Davidson, Henry M. *History of Battery A, First Regiment of Ohio Vol. Light Artillery*. Milwaukee, WI: Daily Wisconsin Steam Printing House, 1865.

Denslow, William R., and Harry S. Truman. *10,000 Famous Freemasons from K to Z Part Two*. Whitefish, MT: Kessinger Publishing, 2004.

Dufour, Charles L. *Nine Men in Gray*. Lincoln: University of Nebraska Press, 1993.

Ehle, John. *Trail of Tears: The Rise and Fall of the Cherokee Nation*. New York: Anchor Books, 1988, 1989.

Farwell, Byron. *The Encyclopedia of Nineteenth-century Land Warfare: An Illustrated World View*. New York: W.W. Norton & Company, 2001.

Hall, J.H. *Biography of Gospel Song and Hymn Writers*. New York: Fleming H. Revell, 1914.

Haynie, J. Henry. *The Nineteenth Illinois: A Memoir of a Regiment of Volunteer Infantry Famous in the Civil War of Fifty Years Ago for Its Drill, Bravery, and Distinguished Services*. Chicago: M.A. Donohue & Co., 1912.

Bibliography

Heidler, David Stephen, Jeanne T. Heidler and David J. Coles. *Encyclopedia of the American Civil War: A Political, Social, and Military History.* New York: W.W. Norton & Company, 2002.

Henderson, Aileen Kilgore. *Stateside Soldier: Life in the Women's Army Corps.* Columbia: University of South Carolina Press, 2001.

Hodler, Thomas W., and Howard A. Schretter. *The Atlas of Georgia.* Athens: The Institute of Community and Area Development, University of Georgia, 1986.

Johannsen, Robert Walter. *To the Halls of the Montezumas: The Mexican War in the American Imagination.* New York: Oxford University Press, 1985.

Keith, Charles Penrose. *The Provincial Councillors of Pennsylvania 1733–1776.* Baltimore, MD: Genealogical Publishing Co., Inc., 1997.

Kington, Donald M. *Forgotten Summers: The Story of the Citizens' Military Training Camps, 1921–1940.* San Francisco: Two Decades Pub, 1995.

Lowry, Amy Gillis, and Abbie Tucker Parks. *North Georgia's Dixie Highway.* Charleston, SC: Arcadia Publishing, 2007.

Macfarlane, Malcolm. *Bing Crosby—A Diary of a Lifetime.* Lanham, MD: Scarecrow Press, 1998.

McDaniel, Susie Blaylock. *Official History of Catoosa County, Georgia.* Dalton, GA: Gregory Printing & Office Supply, 1953.

McWhiney, Grady. *Braxton Bragg and Confederate Defeat.* Vol. 1. Tuscaloosa: The University of Alabama Press, 1969.

The Mexican War and its Heroes. Philadelphia: J.B. Lippincott & Co., 1860.

Mooney, James. *Myths of the Cherokee.* New York: Barnes & Noble, 2007.

Moore, Brenda L. *To Serve My Country, to Serve My Race: The Story of the Only African American WACS Stationed Overseas During World War II.* New York: New York University Press, 1996.

Bibliography

Moorman, John Jennings. *Mineral Springs of North America: How to Reach, and How to Use Them*. Philadelphia: J.B. Lippincott, 1873.

Neiberg, Michael S. *Warfare and Society in Europe: 1898 to the Present*. New York: Routledge, 2003.

Nevin, David. *The Mexican War*. Alexandria, VA: TimeLife Books, 1978.

Nichols, Edward J. *Zack Taylor's Little Army*. Garden City, NY: Doubleday & Comp., Inc., 1963.

Paige, John C., and Jerome A. Greene. *Administrative History of Chickamauga and Chattanooga National Military Park*. Denver: Colorado National Park Service, United States Department of the Interior, 1983.

Phillips, Joyce B., and Paul Gary Phillips. *The Brainerd Journal: A Mission to the Cherokees, 1817–1823*. Lincoln: University of Nebraska Press, 1998.

Putney, Martha S. *When the Nation was in Need: Blacks in the Women's Army Corps During World War II*. Lanham, MD: Scarecrow Press, 1992.

Rodenbough, Theophilus Francis, and William L. Haskin. *The Army of the United States Historical Sketches of Staff and line with portraits of Generals-In-Chief*. New York: Maynard, Merrill, & Co., 1896.

Stevens, Peter F. *The Rogue's March: John Riley and the St. Patrick's Battalion, 1846–48*. Dulles, VA: Brassey's, 1999.

Stout, Samuel Hollingsworth. *Papers of Samuel Hollingsworth Stout*. State of Tennessee, Department of State Library and Archives, 1822–1903.

Thornton, Russell, C. Matthew Shipp, and Nancy Breen. *The Cherokees: A Population History*. Lincoln: University of Nebraska Press, 1992.

United States Government Printing Office. *United States Congressional Serial Set*. Washingtom, D.C.: U.S. Government Printing Office, 1891.

Wood, William J. *Civil War Generalship: The Art of Command*. Westport, CT: Greenwood Publishing Group, 1997.

Bibliography

Yellin, Emily. *Our Mothers' War: American Women at Home and at the Front During World War II*. New York: Simon and Schuster, 2004.

Online Sources

About North Georgia. http://ngeorgia.com.

American Society of Composers, Authors and Publishers. http://www.ascap.com/press/2006/112706_xmassongs.html.

Chickamauga and Chattanooga Administrative History National Park Service. http://www.nps.gov/history/history/online_books/chch/adhit.htm.

Chickamauga and Chattanooga National Military Park Georgia, Tennessee. http://www.nps.gov/chch.

The Georgia Archives. www.GeorgiaArchives.org.

The Great Locomotive Chase. http://www.andrewsraid.com.

The New Georgia Encyclopedia. http://www.georgiaencyclopedia.org.

The Official Records of the War of the Rebellion. http://www.civilwarhome.com/records.htm.

Top 10 Visited National Memorials. http://www.forbestraveler.com.

ABOUT THE AUTHOR

At the age of nine, Jeff O'Bryant became an Abraham Lincoln enthusiast, and from that point forward he developed an ever-expanding interest in other areas of historical study. He is a graduate of the University of West Georgia and holds two degrees, a bachelor of science in education and a bachelor of arts in history with honors. His political column, "In My Write Mind," appears in the *Catoosa County News* and the *Walker County Messenger*.

Please visit us at
www.historypress.net